Praise for *Bursts of Brilliance*

"In our decades helping writers, we've often been asked to name the single most important trait an aspiring creative should cultivate. The answer is simple. It's courage. The courage to put one's work into the world, to bare one's soul, to subject oneself to criticism and even derision. The courage to create. In this wise and compassionate book, Teresa Funke provides artists of all stripes with a road map to developing an inexhaustible supply of bravery.

"*Bursts of Brilliance for a Creative Life* is a work to revisit again and again, whenever the slings and arrows of the creative process test one's resolve. It is nothing short of a call to our higher creative selves to get started, to persevere, and, ultimately, to triumph. Be brave and share your work with the world. With this book, you now have a steadfast friend at your side."

Jon Bard & Laura Backes, WritingBlueprints.com

"As an expert on overcoming perfectionism and creative blocks, I know that shame is one of the main causes of both. Teresa's book, *Bursts of Brilliance for a Creative Life*, offers many solutions for neutralizing that shame, so you can go on to live the joyfully creative life you've always dreamed of."

Hillary Rettig, author of *The 7 Secrets of the Prolific* and *The Lifelong Activist*

"A random Twitter search for authors led to the pleasant surprise of finding Teresa Funke's blog, *Bursts of Brilliance for a Creative Life*. After I read my first post, I added the blog to the top of my Feedly list so I'd be sure to see new articles as soon as they were released. I believe creativity is the birthright of every human being, not just the artistic ones. This book will be an ongoing source of inspiration and encouragement for all of us who want to stoke our creative fires. Share it with everyone who is ready to give their imagination a boost!"

Franklin Taggart, business coach for creative professionals

"As a certified Happiness Ambassador and Peak Performance Coach, I love how Teresa combines such diverse topics as clutter clearing, reframing shame, and embracing the full potential of your creative self in this uplifting, action-oriented, and simple-yet-profound book. Whether you need a boost in energy, morale, or an increase in your happiness-factor, *Bursts of Brilliance* is a must-read."

Kathryn Kemp Guylay, MBA, CNC, bestselling author
and founder of MakeEverythingFun.com

"With the heart and analysis of a historian and an artist's vision and soul, Teresa Funke's *Bursts of Brilliance for a Creative Life* takes us to a place of encouraging real-life guidance. As a business owner and executive coach, I often find myself referring to her blogs and book to help my clients and myself feel more artistically inspired. To follow the writings of Teresa Funke is the most Brilliant choice ever."

Hilary Blair, CEO and speaker, Articulate Real and Clear

"Teresa is a beautiful writer who takes you into her world like an old friend. She inspires you to live the life you were meant to live and to recognize how talented, unique, and impactful you are. Her nuggets of wisdom in *Bursts of Brilliance* give you hope for who you are and what you want to create now and in the future."

Jean Marie DiGiovanna, speaker, executive coach, author/artist

"Eloquently written and with great insight, Teresa Funke's writings will resonate with anyone who has wrestled with finding a greater sense of mindfulness and peace while struggling with the solitary life of the creative process. *Bursts of Brilliance for a Creative Life* is a wonderful resource, no matter what your age or level of experience."

Jephta Bernstein, founder and executive director, Off the Hook Arts

"The insights we can gain by embracing Teresa Funke's wisdom in *Bursts of Brilliance for a Creative Life* will help us each live a happier life that is more congruent with our life mission. Her accessible style and commonsense approach make reading the book a delight!"

Jill S. Tietjen, P.E., co-author of *Her Story: A Timeline of the Women Who Changed America*

"Whether working with writers in classrooms or in film production meetings, I've learned that creative people need to nurture their spirits as much as their craft. *Bursts of Brilliance* connects creatives to the inspiration so essential to their process and success. We need this book."

Trai Cartwright, story development professional, Craftwrite

"In my 25 years of coaching leaders and physicians, I have noticed that many of my clients struggle with the impostor syndrome, emotional exhaustion, and disconnection from meaningful work. Teresa Funke provides real stories that generate higher awareness for readers, which leads to new actions to connect them to their best self. Her book *Bursts of Brilliance for a Creative Life* provides support and practical tools for all of us to live a more authentic life."

Sandy Scott, president/CEO of Sandy Scott Consulting Group

"Teresa's insights on the creative journey are thoughtful and inspiring. *Bursts of Brilliance* is like having your own personal coach providing support and cheering you on. Highly recommended!"

Stephanie Chandler, author and CEO, NonfictionAuthorsAssociation.com

BURSTS
of
BRILLIANCE
for a CREATIVE LIFE

Also by Teresa R. Funke

To find more resources, materials, and personal connections to ignite your Creative Self, please visit www.burstsofbrilliance.com

BURSTS
of
BRILLIANCE
for a CREATIVE LIFE

TERESA R. FUNKE

To Stephanie –
Honoring your
unique brilliance!
Thank
you,
Teresa
Funke
2019

VICTORY
HOUSE
PRESS

This book is available at special quantity discounts for bulk purchases for sales promotions, premiums, fund-raising, and educational needs. Book excerpts can also be created to fit specific needs. For details, contact Victory House Press.

Published by:

Victory House Press
3836 Tradition Drive
Fort Collins, Colorado 80526
www.victoryhousepress.com

Library of Congress Control Number: 2019905102

Printed in the United States

ISBN 978-1-935571-43-8

This book is dedicated to my Creative Self,
with gratitude for all the joy and purpose she has given me—
and all the times she has refused to let me give in.

And to your Creative Selves and all the brilliant ways
they will light up this world.

Contents

Introduction

Few things excite us more than a great idea, especially when it's one of our own. Observe a person's body language, listen to the passion in their voice, watch the light fill their eyes when they say those magic words, "I have a great idea," or "Listen to this," or "You know what we should do?" In those moments we are brilliant, and we know it!

I have a friend who started a business in his basement. Whenever something good happened with his work, he'd fly up the stairs, fling open the door, and shout to his wife, "I'm a goddamn genius!" And in that moment, he was. You've had that feeling, right? At work, at home, at school, at your workbench or studio or writing desk. I know I have.

When I was a teenager, I had a Louisa May Alcott quote taped to my mirror that read, "Far away there in the sunshine are my highest aspirations. I may not reach them, but I can look up and see their beauty, believe in them, and try to follow where they lead." At different points in my life, that quote held different meanings. The other day, I took it down.

See, I've lived long enough and been lucky enough to have achieved some of my highest aspirations and to realize that

dreams *can* come true. They don't exist "far away" but right here at our fingertips. And many of the dreams that don't come true lead us to something better. Something we never would have gained if we'd achieved what we thought we wanted.

When I was 24 years old, I quit my dead-end job to become a freelance writer, not even sure what that meant. My husband of six months fretted. We needed the $600 a month I'd been making to pay our rent. But he didn't try very hard to talk me out of it, and he has supported my career ever since.

I have a picture of myself at that time, typing on a crappy new word processor because I couldn't afford a computer. I could have stuck with my electric typewriter, but I wanted to feel more cutting edge.

For the next 25 years, my career meandered from freelance writing for newspapers and magazines, to penning short stories and personal essays, to dabbling in commercial writing, to writing historical fiction books, to speaking and school visits, to writer's coaching, to a one-woman show, to blogging, to webinars and products, and so much more. My career has paid some bills and allowed me to stay home with my kids, and it has brought me so much joy. I hope it has also helped people connect with history and with their own inner artists.

This book is about celebrating and honoring those bursts of brilliance that hit each of us every day. It's about believing our creativity is boundless, and the very fact that we had the thought at all is miraculous. It's about relishing spontaneity—

dropping everything to jot down an idea, to text it to a friend, to rush across the room to tell a coworker. It's about drawing energy from that initial burst of brilliance whether you act on the idea or not. It's not about success or failure, it's about creativity and passion and the joy of discovering the amazing insights we never knew we had. It's about the power of art in the world to connect and inspire. And it's about art as a tool and a gift to connect us to our Higher Selves.

I'm grateful for the artists who are brave enough to let their brilliance shine. The writers, poets, singers, musicians, dancers, actors, filmmakers, photographers, painters, sculptors, potters, weavers, architects, and craftsmen whose art is the axis on which this world turns. Without artists, we'd have no understanding of cultures long gone. It is their pottery, cave paintings, and temples that we study to learn who they were. It is their stories and songs, passed on for generations, that reveal their beliefs and values.

People do not line up outside of banks to stare at piles of money or outside of most factories to watch products being built. But they do line up outside of the Louvre in Paris to see the great works of art. They do line up to purchase concert tickets for their favorite bands. Our minds, bodies, and egos need material goods, but our souls need art.

And when dictators, tyrants, or terrorists seek power, it is the art they try first to destroy. Why? Because art unites us, and tyrants wish to divide us.

Not a single day will go by in your lifetime when art will not affect you. Not one day will pass when you don't read a book, watch a movie, listen to music, walk past a picture hanging on a wall, hum a song, tell a story, snap a photo, or say a prayer that someone once wrote.

Artists are mirrors. They reflect humanity back to itself. They ask, "What do you see?" And we all answer.

It's time to embrace the artistic genius in *all of us* with no apologies and no hesitation. Because whether your idea changes your life, your community, or your world, once it's out there, nothing will ever be the same.

Revealing the Brilliance Within

WE MAKE WHAT MATTERS, MATTER

The line is a quote from Mildred Shearer, one of the women I interviewed for my book *Dancing in Combat Boots: and other Stories of American Women in World War II*. Mildred's contribution to the war effort continues to inspire me. She quit a lucrative job to sketch wounded soldiers in their hospital beds and at USO events. She sketched over 3,000 men! For many, it was the last likeness made of them before they died in the war. Mildred sent the originals to the soldiers or their families and kept copies for herself.

In my interview with Mildred, she told me her mother used to say, "We make the things that matter, matter." What Mildred did during the war mattered a lot to the men who carried her sketches into battle, to the families who framed her drawings of their sons and husbands, to the exhausted nurses and doctors who welcomed her visits with their patients.

It was a short-term job in a war long over, but her work still matters. Why? Well partly because I decided it should, and so should the other stories I wanted to tell. Partly it matters because today, once again, I'm thinking of Mildred and honoring her memory. And partly it matters because the legacy of

her gift still lingers in this world in ways we may never see or recognize.

We tend to think what matters is decided by society or culture or religion or our peers, but no one can say what truly matters except us. You may feel passionate about preserving the rain forest and your friend may see no point in that. Who is right? Him or you? We make the things that matter, matter. We decide.

So, what matters to you? And what do you plan to do about it next? Change your job? Change your art? Change your attitude? Change your destiny? What will *you* do that matters?

O

THE HAPPINESS OF ART

In the book *The Artist's Way,* Julia Cameron makes a fascinating point. She says that productive artists are often happy people, and this is threatening to those who think it necessary to be unhappy.

As a society, we continue to hold on to the concept that artists must "suffer" for their art. Why? How can anyone in a down and negative place produce anything of beauty and value for the world? I'm not saying that art always springs from a place of gladness—you can write a great love song after experiencing heartbreak, for example—I'm saying that choosing to suffer for the sake of suffering will get you nowhere.

The other night, I attended a reading given by some author friends. They had also invited a singer to open with a few of her songs and a visual artist to paint something quickly on the stage. And here is what made the night a huge success: they were happy. All of them!

The authors read from their work, big smiles on their faces. Their voices rose and fell with the rhythm of their words, as they savored every syllable. The singer picked up her guitar

and eased into her songs. Her eyes often looked up at the heavens, as if we were not even there, and she radiated joy as she sang. The artist took to the stage and gingerly picked up her paintbrush. As my friend read, the artist put a few brush strokes on the canvas. Though her time was limited, she was in no hurry. She was enjoying the moment, as were we.

If your art is bringing you nothing but frustration, pain, confusion, and anguish, don't pick yourself up and carry on thinking that's just the plight of the artist. Do something else for a while. It's okay to take a break. Find your joy again, and then share it with us.

I FEEL PRETTY

When I was a kid, my dad used to sing the song "I Feel Pretty" from the movie *West Side Story*. Yes, my *dad*. When I was little, I thought the song was about this hopelessly stuck-up girl who liked to brag about her good looks. Catchy tune or not, I couldn't understand why Dad liked it.

As I got older, I realized Maria wasn't boasting, she was simply giddy with happiness. Why? Because Tony was in love with her, and his love made her feel not only pretty but also witty and charming and gay.

That's how it feels when someone likes our art. When we get a complimentary e-mail or a social media shout-out or an award, we feel all those things and more. And like Maria in the show, we think the city should give us its key.

It's not a feeling that necessarily lasts. Later that same day, we may face a harsh critique or a creative block or a rejection. Nothing in life is permanent. Things are changing by the moment, even our moods. But that's all part of the journey. Think how boring life would be if everything were always the same.

So, for those few glorious moments when someone sees, really *sees*, your art and bothers to tell you, relish it! Boast to a

friend, brag to a family member, show off to a colleague, dance around your kitchen. Because for those few minutes, life is pretty in every way.

○

WHAT'S YOUR DREAM?

You know the video clip on YouTube featuring Susan Boyle singing "I Dreamed a Dream" on *Britain's Got Talent*? I'm sure you do. It has millions of views, and I think at least 50 of those are mine. This is my go-to video, the one I watch anytime I want a pick-me-up or I feel the need to believe anything is possible. It's positively brilliant, as the Brits would say.

Here is this middle-aged woman who looks like your goofy neighbor, and she shocks the audience by nailing a very difficult Broadway ballad. It's the ultimate underdog story starring an artist. And it's full of wonderful clichés: don't judge a book by its cover; it's never too late to achieve your dreams; you can slay the dragon (Simon Cowell). And then there's the lovely irony of a woman whose dreams are coming true as she sings a song about dying dreams. Perfect!

Shortly after he won the Caldecott Medal in 2015, I read an interview with Dan Santat, in which he described always wanting to feel "as good as." If getting one of the highest honors in children's literature doesn't let you know you've arrived, nothing will. Can you imagine his excitement as he accepted that award?

Frankly, I think that's what life is all about—those moments when our dreams come true; when our faces threaten to split because we're smiling so wide; when we shake our heads in utter disbelief; when we cry from sheer relief; when we laugh so hard we can't stop; when we fall in love so deeply it dazzles.

And it doesn't matter what those moments look like to you. Many of us felt them when our children arrived or the first time we flew solo or finished a marathon. Most of us recall a thrill when we kissed someone we thought might be "the one."

No matter how old we get, we must never become so set in our ways, so tired and complacent, so overworked and cynical, that we stop reaching for our dreams. Strive for achieving those highest moments in your art and in your lives. If you can't do that for yourself, do it for us. Because the best part of the Susan Boyle video isn't her miraculous voice, it's the reaction from an audience that is experiencing magic. Inspire us, please!

○

CALL ME ARTIST

My husband was recently asked by his boss to retake the Myers-Briggs test. His result was ISFP, also known as "The Artist." When he saw the word *artist* and read the description, it shocked him. He figured he must've done something wrong, so he had me watch as he retook the test. I did, even offering a little input, and his result was the same. He was no less unsettled the second time.

See, my husband views himself as practical, logical, and analytical. He has worked for the same large corporation for almost 30 years. His main goal for his career was to have an 8:00–5:00 job with a wage that would allow him to provide well for his family, and he has achieved that. Never in a million years would he have described himself as an artist. That was my territory.

Yet, my husband is a master woodworker. He builds incredibly beautiful furniture, shelves, and cabinets. He can see a picture of a three-tier snowman cake in a recipe book and figure out how to make it. When the kids wanted some crazy costume made for Halloween, he was the one they went to. He is now crafting unique and beautiful ukuleles out of woods I didn't

know existed. The only difference between my husband and me is that, years ago, I decided to call myself an artist, and he never has.

Last week we took one of his ukuleles to a mountain town to see if one of the galleries there would sell it. My husband, who has overseen multimillion-dollar budgets, managed teams of more than a dozen people, and spoken before high-level executives, suddenly looked nervous, and I get that. Putting our art out there is one of the biggest risks we can take. It's a special kind of vulnerability. It takes guts to be an artist. And it takes guts to admit we *are* artists.

I remember the day someone asked me, "So, what do you do for a living?" and instead of answering, "I'm a stay-at-home mom," like I usually did, I took a deep breath and said, "I'm a writer." From that moment on, I owned it in a way I never had before. If you haven't proclaimed it in your own life yet, do it now. Say, "I'm an artist." It doesn't mean you have to quit your job or make a drastic change, it just means you're opening the door to exploring a fuller version of yourself.

The second gallery owner we approached took my husband's ukulele on consignment. We'll see how long it takes to sell. He's already at work on another one. My garage is covered in sawdust, but my husband is happy. And *that* is why we pursue our art.

Bursts of Brilliance for a Creative Life

ARE YOU A SERIOUS ARTIST?

Recently, I was listening to a young artist describe his approach to his work, and it all sounded so familiar. Emerging artists get caught up in the "romance" of their calling. In their determination to be seen as "serious artists," they embrace dark and heavy topics; they question whether drugs or alcohol will help them tap into deeper wells of creativity; they don the costumes of the "brooding artist"; and they beat themselves up for not having the "answers." He was doing all those things.

If you came to your art later in life, maybe you didn't go quite this far, but you probably still worried that people wouldn't "get" your art. You wanted so desperately to connect.

At a certain point, though, something happens in an artist's journey. You realize this whole thing is a pull, not a push, as they say in marketing. You're not pushing your art on the world hoping people will like it and respond to it, you're pulling people toward you who share a common interest or appreciation for the work you produce.

But artists are human. Which means we'll experience ups and downs in our lives and careers, and the emotions that follow will make their way into our work. We'll explore heartache

and anger and frustration, but we'll also explore love and joy and empathy.

You'll know you are a "serious artist" when you're doing the work that feels best to you, work that gives you a sense of purpose, work that *inspires* you. You'll know you're serious when it becomes less about what you're going through and more about what you've learned.

Edgar Allan Poe was a serious artist, but so is Jerry Seinfeld. Don't let a stereotype define you. You don't have to be "tortured" in order to be good, you just have to embrace your gifts and trust where they take you.

O

PERFECT IS NOT ALWAYS BEST

There is a sculpture not far from my house that is a representation of one of our town's early residents. It sits on a pedestal at the corner of a busy intersection, and visitors and locals often asked two questions about the piece: "Who is that supposed to be?" and "Why is his head so big?"

The answer to the first question is Antoine Janis, the first white settler in our county. The answer to the second was "artist error." Recently, the artist decided to correct her mistake and received permission to remove the statue and reduce his head size by 15 percent.

The "new and improved" Antoine Janis is now standing once again on that same street corner, and the artist is pleased with her adjustment. You would think I would be too, but I'm not. I miss his big head.

It's true that Antoine looked a little "funny" with his oversized skull, but I came to love him that way. His big head made him unique. It gave him character. It made him stand out. And it certainly got him noticed. His confident stance sort of made up for his "deformity." It was like he was saying, "Yeah, I'm odd, but that's me. Take me or leave me."

Now Antoine looks "normal," and no one asks about him anymore. I used to talk to him when I drove by. "Hey, Antoine, what's with the giant noggin?"

"Hey, buddy, how do you hold that thing up?"

"Lookin' good, Antoine. The shadows today have slimmed up that head of yours." Now, I've got nothing to say. He's just plain, old Antoine.

So, maybe better is not always best. Maybe sometimes our screw-ups are more endearing than our "perfect" pieces. Though it's tempting to correct our mistakes, maybe sometimes we should let them stand.

The point is to produce the best art of which *we* are capable and put it out in the world. There will be those who declare it perfect, even though it's not, and those who point out flaws no one else sees. For the rest of our lives, we will look at our own works and notice things we wish we had done differently. That's human nature. We're programmed to never be satisfied.

Here's my take on the quest for perfection: if striving for perfection guides you toward your best work, follow that track for a while. Then jump the track before it leads you round and round in circles.

Beauty is in the eye of the beholder, and I thought Antoine was once quite handsome, big head and all.

○

ALL THAT MATTERS IS YOU NEVER GIVE UP

The other evening, my husband and I were strolling around downtown and popped into one of my favorite art galleries. I bought a couple of note cards and a glass nail file, and as we were leaving, I heard someone say, "Are you the author? The book editor?"

"I'm Teresa Funke, yes."

"I had a meeting with you a few years back so you could look at my book," the gentleman said. He described his project briefly, and I recalled our consultation. "You told me it needed work, and I was pretty upset," he said.

"Yes, I remember that. Usually when I meet with a client, I'm able to leave them feeling at least hopeful, but I remember thinking you seemed more down than I'd typically experienced."

"Oh, it wasn't you," he said. "You were very kind and I trusted your opinion. It's just that I was at one of the lowest points in my life and your advice was the last thing I wanted to hear. But you'll be happy to know our meeting turned out to be a good thing. Afterwards, I couldn't bring myself to work on the book

anymore, so I went back to my painting, and now look at me! My work is hanging in galleries, I've sold a few pieces, and I've even been invited to show some of my work in Europe. I'm going to Europe!"

"That's wonderful," I said. And then he showed me his beautiful pieces, and we talked about his unique process.

"Who knows," he said, "maybe someday I'll go back to the book. Maybe I won't. But in the end, I realized something. It doesn't really matter which direction you take with your art, all that matters is that you never give up."

I couldn't have said it better myself.

○

GETTING BACK TO WHAT YOU LOVE

When I was in junior high and high school, my teachers told me, "Teresa, you're a very good writer. You should be an author someday." And I took their advice happily. It's all I ever really wanted to be.

After my first novel came out, I started speaking about my book, and the event coordinators told me, "You're one of the best presenters we've ever had. You should be a speaker." And I took their advice happily. Speaking gives me great pleasure.

After I started speaking, people told me, "You're good at explaining things, you should develop some workshops or classes." And I took their advice happily. I love sharing my knowledge.

After I started instructing, people said, "We wish we had more time and access to you." So, I decided to become a coach. I got great satisfaction out of helping others improve and reach their goals.

Before I knew it, though, I didn't have one job (writing), I had several, and each year new projects were also added on. Like many artists and entrepreneurs, I enjoy reinventing my-

self, learning new skills, moving in different directions. And like any successful businessperson, I understand the need to change with the trends and markets, but the more spread out I became, the less effective and more tired I felt. And the busier I got, the more I drifted away from my art. I was so preoccupied running the business and tending to others, I lost myself in the bargain.

Now don't get me wrong, I enjoy everything I do, but I'm clearing some things off my plate to get back to what I love most, writing.

Are you doing too much, working too hard, spreading yourself too thin? What can *you* clear from your life to make time for your art?

○

ARE YOU COOL ENOUGH TO BE AN ARTIST?

Not long ago, my youngest daughter and I were talking about high school popularity.

"But, Mom, you weren't cool in high school, right?"

"Oh, I was extremely cool," I said. "It's just that no one knew it."

See, from my point of view, being popular in high school (for most people) meant giving up part of yourself. Maybe in junior high you wore Star Wars shirts to school every day, but in high school, if you wanted to hang with the popular kids, you had to stop. You had to change your hairstyle and the way you talked and ditch some of your old friends. Some of the popular kids *appeared* to be blazing their own trails, but once those trails were cut, they were sort of stuck. If they wanted to veer a different direction, they couldn't. People now expected something from them.

And this bookish, semi-nerdy, goody-two-shoes actually liked herself the way she was. I had no intention of giving up carrying a novel with me everywhere I went or cutting my waist-length hair or dumping a single friend I still liked. I wanted to do the things that made me happy and filled me with creative energy, and if those things were not cool, so be it.

That's how I approach my art too. There are decisions I could have made along the way that would have put me a bit closer to the "in crowd." I could've chosen a more popular genre, or gone with a traditional publisher, or written about people who already had name recognition. Instead, I stuck with the things that gave me excitement, fulfillment, and a sense of purpose.

The interesting thing about the arts, though, is that not everyone who is seeking popularity achieves it. To try to manufacture the cool factor is harder than it looks. On the flip side, I've known many an artist who doubted their work would ever be popular and it took off.

The question then is not whether you or your work is "cool" enough to succeed, the question is whether you're remaining true to yourself. Because trust me, you *do not* want to play games in order to succeed, nor do you want to compromise your beliefs, principles, or talents. You'll then be stuck in a trap of your own making. Instead, focus on your strengths and the things that give you energy, and if they make you popular, great. And if not, at least you can walk down the hallway with your head held high.

O

FIND YOURSELF IN YOUR ART

The Lady in the Van is a movie based on the true story of a writer, Alan Bennett, who allows a homeless woman to park her van in his driveway. In helping her, he learns a few lessons about himself. There's a line in the movie that stuck with me. Alan says, "You don't put yourself into what you write, you find yourself there."

As artists, we're often asked, "How much of yourself did you put into that story, picture, or role?" And people always seem a little disappointed if the answer isn't, "A lot."

In reality, this question has many layers. I believe a little bit of who we are or who we once were makes it into every piece of art we create. It certainly affects the themes we explore. Other times, we pull inspiration from people we know. There's a lot of my brother and my husband in one of my characters, for example. But sometimes, we entertain or challenge ourselves by forging art that is nothing like us. Or maybe we create art that captures who we wish we were.

Many artists mistakenly believe they *should* put themselves into their art. Even Alan's character makes that mistake at first. But the truth is closer to his realization at the end of the film.

Good art starts with a quest to *find* yourself. Seasoned artists often begin projects because we've observed or heard or experienced something that won't let us go, and we want to know *why*. We want to know why it bothers us so much when someone comments on our appearance, or why beautiful gardens make us cry, or why we've suddenly become addicted to social media.

These questions are often sparked by a single incident that just keeps replaying in our minds. And they can be sparked by the strangest observations. For example, I've noticed when women lose their place or have to keep you waiting, they make funny noises. They say, "doot da doot da doo" or "la, la, la, la, la." But men never do that. Why is that? Why do we women feel we have to "make light" of our confusion? If I write an essay about that, I might "find" myself in that essay, because it probably has something to do with my increasing interest in what holds women back.

I believe an artist's task is to be always seeking to find himself/ herself. That may sound selfish or egotistical, unless you accept that we are all, not just artists, on this planet to do just that: to complete our personal journeys. And as we find ourselves and show that in our art, hopefully we help others find themselves as well, just as the homeless woman, Miss Mary Shepherd, did for Alan.

Bursts of Brilliance for a Creative Life

IT'S ABOUT TIME FINDING YOU

At least once a week someone tells me, I'd love to pursue my art, but I simply can't find the time. To which I say, it's not about your finding time…it's about time finding you. It's about making a connection to a project so captivating, you simply *have* to work on it. It's about the dishes piling up in the sink and the dog going unwalked and the paperwork getting ignored because time demands you work on that story or painting or new product.

I remember once sitting in my moms' group when my kids were little and complaining about how hard it was to keep up with all the chores. One mother shrugged and said, "I never worry about it. If it's a priority, it will get done. If not, it won't." That comment changed my attitude forever. Are the things you currently think of as necessary really priorities? If you gave up social media for a week and used that time on your art, could you start a project that would entice you? If you turned off the TV for one night, could you jot down some ideas that might actually excite you? If you took a day off work and devoted it to your art, could you find your passion?

Time is not the master, it is the obedient servant. It will stretch and weave and rearrange itself to serve you. So, I promise, once your art starts calling to you, time will follow. In fact, you'll lose track of it. You'll look up at the clock and the whole evening will be gone. And the laundry will still be in the basket, and your e-mails will go unanswered, and your kids won't pick up their shoes, and who cares? Once those things pile up, *they* will become the priority. Until then, why not enjoy your art?

O

WANT TO KNOW THE SECRET
TO BEING A GREAT ARTIST?

The secret to being a great artist is being observant. Yep, it's that simple. Regardless of your level of skill or talent, you can still make a connection with an audience if you simply learn to listen, notice, feel, and experience the world around you.

Ask any writer who is good at dialogue what her secret is, and she'll tell you, "I listen." I lurk around coffee shops and malls and networking groups and bars and I listen. I listen to how you talk to your children and how they talk to you; how you sound when you're frustrated and how you sound when you're happy; what you have to say about a current issue and what you say when you don't want to talk about it.

Ask any painter how he captures light or color so perfectly and he'll tell you, "I notice." I notice how the light streams through closed blinds and hits the plant on the table or how the red in a tulip changes when the sun dips behind a cloud. I notice the way the pink in your shirt highlights the blush in your cheeks or how the color of the wine in this glass changes when I hold it up to the light.

Ask any songwriter how she so perfectly captures emotions in her songs and she'll tell you, "I feel." I take note of how it feels to have my heart broken or to hold a new baby in my arms. I stand on the edge of a cliff and notice how it feels to have my toes dangling over the edge, and I stand in a corner and feel alone in a room full of people. Sometimes I sit on a swing and pump my feet as hard as I can to remember how it feels to fly.

Ask any dancer how he makes you believe he's dancing in the snow and not on a bare stage and he'll say, "I tap into the experience." I go outside when the first flurries fall and stretch out my bare arms to feel the flakes land on my skin, or I close my eyes and imagine a world of white and cold. I turn down the heat in my apartment while I practice, and on the night of the performance, I try to remember everything I've ever known about cold and snow and beauty and belonging.

All it takes to be a great artist is to be aware—to take note of the world around you, not rush through it or past it. We all know how to notice. We did it all the time when we were babies and toddlers. We noticed everything then. It's still in us, we just have to remember. Try it now. Look around the room. What do you see, hear, smell, taste, touch? And how do those things make you *feel*? In that connection lies your art.

O

DOODLING YOUR WAY OUT OF STRESS

I heard reference to a study that said many of us spend 70–80 percent of our waking hours stressing about something. We stress about our jobs, our families, our health, our friendships, traffic, the environment, climate change, gun violence, world conflicts, upcoming elections, and so much more. And there is no longer a cultural attitude toward a "day of rest." Remember when we were kids and people took leisurely Sunday drives or spent Sunday afternoons at the park? Now we stress 24/7.

Lately I've been hearing people say, "Things have never been as bad as they are now." As a historian, though, I know that's not true. Things *have* been as bad as they are now and sometimes worse, and somehow, we humans continue to survive and thrive.

One way we do that is by turning to art. We finish a stressful day by watching a sitcom or renting a funny movie. We read books to unwind. We make time to throw pots or paint a picture or sing with the church choir. And every time we do, our stress lessens, our chests untighten, our breath slows, and our imaginations tell our worried minds to shut up and let them take over for a bit.

We all know about the rise in art and music therapy programs and the successes they've achieved. And we've read about the importance of play (for adults and children). But so many people tell me they don't have time for their art. In this day and age, can you really afford *not* to make time for your art? In the same way you try to cook nutritious meals or stop by the gym after work, being healthy means making time to create.

Even if all you can squeeze in on a certain day is a few songs in the shower or cutting your kids' sandwiches into funny shapes or just doodling during that boring meeting at work, do something! Every day. Art can be serious, of course, but it doesn't always have to be. Sometimes it's okay to just play. For heaven's sake, love your body, mind, and soul enough to give them a break. Give them art!

O

SIX IMAGES A DAY

I haven't written much poetry since high school. I would never have described myself as a poet, nor did I think I'd ever want to. But recently I wrote a poem that sort of came gushing out, mostly because it was something I'd been wanting to write about for years, but the topic was too big for a short story or an essay. It had to be a poem. Sometimes the larger world can only be expressed in the fewest words.

So, I was intrigued when my poet friend mentioned she keeps an "image journal." In it, she records six images she sees every day. No explanation or setup, just the image: cat lying on back, blue flower in vase, red apple on a table. Then she just holds onto it for a while. Maybe in time, several join together to form a poem. Or maybe one image inspires its own verse. I'm not entirely sure how it works, but it's a lovely way to record time and space, and more importantly, heart and soul.

I thought this might be a good experiment while spending some time on the enchanting island of Ireland. Here are my images for one of the days:

- Painter's light on the hilltops
- Clouds in the water

- White-winged birds skimming the bay

- A red broken dock

- Tiny white daisies in the emerald green grass

- A wooden rowboat

Those are the first images that came to mind, but they will forever remind me of a very special evening when that magical Irish light pulled us out of our cottage and down to the water. They will remind me that I'm blessed and that nature brings a calm like no other. They will remind me that in this land of beauty and music and passing smiles, there has also been so much suffering and sadness. And they will remind me that creativity is heightened when we slow down, sit still, and just notice.

○

IT JUST FEELS RIGHT

Recently, I was spinning my wheels because there were three projects I wanted to start. Each of them felt equally important and ambitious. It seemed crazy to start all three at once. Current thinking tells us multitasking isn't effective. Plus, there is the business side to consider: the sooner I complete a project the sooner I can earn from it.

Round and round I went trying to figure out how to prioritize the three. I tried looking at the situation logically, I tried ordering them by earning potential, I tried to decide which could be completed in the quickest manner so I could move on to the other two. I considered current markets and which project might have the most appeal. I asked friends for advice. I thought about scheduling an appointment with my business coach. I wondered if I should just put the choices in a hat and pick one.

Then one day, I was due to meet a colleague for one of our "strategy coffees" and I was excited. Maybe she could provide the solution. For some reason, she didn't show up. I was disappointed. There, perhaps, went the answer to my dilemma. In the end, it turned out to be a good thing she missed the

appointment, because across the street from the coffee shop is the university's test garden. It was such a beautiful, sunny afternoon, and the plants were in full bloom, so I decided to go for a stroll.

I passed row after row of neatly planted flowers in every imaginable color. I paused now and then to read the names, Electric Sunshine and Limerick Isabella, and then my gaze was drawn toward a corner of the garden.

"What's *that*?" I said aloud, and beelined for the section. There I found large, round planters filled with various types of flowers of all shapes and colors mixed together, growing in abundance. No neat and tidy rows, just a jumble of blossoms tossed together. And the sight of it made me happy. Ever since I was a child, I've gravitated toward colors all thrown together. When I moved closer to read the sign, it said "Combination," and my heart sighed with relief.

I made my decision at last, to work on all three projects at the same time. It feels the tiniest bit overwhelming to be in the early stages of three creative endeavors at once, but mostly it feels exciting and promising and right. It feels *right*. What feels right to you?

○

Bursts of Brilliance for a Creative Life

FINDING BRILLIANCE IN YOUR ORDINARY LIFE

I've been working on my branding and the messaging for my new website. In running through various exercises to arrive at what I do best, I realized there is a consistent theme in my life's work. Everything I've done—from my books and other writings, to my speaking and presentations, to my community work and activism—has all had to do with celebrating the contributions of "ordinary" folks. Celebrating the brilliance inside us all.

The people who inspired my books were often surprised when I asked to tell their stories. "Oh, you don't want to write about me," they'd say. "I just had an ordinary life." To me, though, sketching wounded soldiers in their hospital beds or working in a war factory at age 14 seemed far from ordinary.

The people who came to me for help writing and publishing their books were not celebrities or CEOs. They were retired teachers and engineers and young mothers with three children and teenage kids with big dreams. They were ordinary people with something to say. Something they hoped others would want to hear. And I honored those hopes.

I've been touched by the ordinary on a daily basis. I've learned the most in my life not from the sages and gurus but from the passers-by who've shared with me their stories, from the schoolkids who have given me hugs, from the strangers who've written to tell me what my work has meant to them.

So, I decided to use the word *ordinary* in my branding—and met immediate resistance from some of my writer friends. "No one wants to think of themselves as ordinary," they told me. Really? Then why is it when celebrities are interviewed, they often say, "I just think of myself as an ordinary person"? In all the rush and chaos of their lives, they cling to the need to be just like everyone else. And why is it that people tell me all the time, "I don't want to be rich or famous, I'm happy being my ordinary self"?

The fact is, whether we are kings or commanders, saints or superstars, we are all, at our core, just ordinary people. We are all one. And we are all brilliant. Every one of us affects the lives of others, encourages greatness, shares our gifts. Every one of us raises the energy in this world when we laugh, love, pray, or create. Every one of us is here for a purpose, and no one is more important than anyone else.

Today, be thankful for your ordinary life, as I am, and the bursts of brilliance that light it up.

PART II

What It Really Means
to Live Your Art

MAKE NO APOLOGIES FOR HOW YOU WORK

The other day, I was conducting an author visit at a middle school, and a sixth grader said, "I read about an author who gets up at five o'clock every morning to write. Is that what you do?"

"Honey," I said, "I don't do *anything* at five in the morning except sleep!"

I then explained to her how you were more likely to find me working on a new scene at midnight than at five a.m. And I told her what I firmly believe, that as artists we need to figure out what systems, methods, techniques, and time schedules work best for us, and then build our lives around those things.

I've gotten plenty of ridicule over my lifetime for being a night owl. I've been accused of being lazy because I'm a late riser and "spoiled" because I've set up a schedule that works best for me. This baffles me. If I go to bed at 1:00 a.m. and get up at 8:00, and you go to bed at 10:00 p.m. and get up at 5:00, we both get the same amount of sleep. So, what difference does it make?

If one person needs all the latest technology to do his art well and another needs only the most modest tools, who is right?

Both, as long as they're doing what makes them feel most comfortable and efficient in their work.

A friend of mine was talking about his artistic son one day. "This boy," he said, "sometimes he just jumps out of bed and heads straight to his computer and gets to work. He doesn't even bother putting on pants."

"Are pants necessary to the task he's doing?" I asked.

My friend looked at me like I was crazy, but I'm not. As artists, we don't have to conform to society's rules if we're not hurting anyone. As long as we're not going bankrupt by buying more tools than we need or causing our family serious distress in any other way, we should never feel the need to apologize for how we work.

And if people want to make fun of us, let 'em. If they want to call us "privileged" or "entitled" or "lazy" or "odd" or anything else, that's their judgment and envy talking. We know how hard we work.

O

OPERATING ON "ARTIST TIME"

The other day, I had scheduled a midmorning coffee with a friend. I did my exercises first and checked e-mail, leaving myself a full hour to get ready. But sometime during that designated time, my creative mind decided to take a walk. I wound up spending twice as long in the shower as I had intended to as this brilliant idea unfurled. I held my foamy toothbrush between my teeth so I could jot down some of my thoughts. I stood in my closet staring in the direction of my clothes but seeing only words marching before my eyes. By the time I finally glanced at the clock, I noted with panic that I had 10 minutes to get where I was going.

If you operate on "Mommy Time," people cut you some slack. They assume you're late because of a lost shoe or an unexpected potty break. If you function on "CEO Time," they might even respect you for running behind, assuming that a very important meeting must have run over. But if you operate on "Artist Time," you get nothing but grief.

In order to avoid the eye rolls, we tend not to mention our tardiness, in the hopes that you didn't notice. If you push us, we might tell a little white lie about a last-minute phone call

or bad traffic. It's only to other artists that we admit the truth. "Sorry I'm late, but listen to this great idea I got!"

Creativity can't be scheduled. Oh, how I wish it could, but, like a spoiled child, it has a tendency to do as it pleases. Some call us artists "flighty" or "distracted" or "disorganized" because we sometimes burn dinner or overflow the bathtub or forget to close the garage door, but should we instead let our great ideas go by, ideas that might turn into our next great book or song or painting, so we can stay on top of the smaller details of life?

Does that mean we can always be late or unreliable? No. I'm almost never late to meetings with clients or to doctor's appointments. I absolutely *can* function within the dictates of time when necessary, but I have definitely lost some great ideas in the process. So, whenever possible, I follow my muse.

One day, I'd gone to collect the mail in the middle of the afternoon, and on my way back, I got an idea. I dropped down in the Adirondack chair on my porch because I was afraid if I stepped back into the chaos of my house, I'd lose it. As I was deep in thought, a neighbor strolled by.

"Working hard?" he said.

"Yep," I answered.

○

HAVE YOU FILLED YOUR TANK LATELY?

A group of writer friends and I were talking about our sudden lack of motivation. We're not behaving like our usual prolific, proactive, hardworking selves. That's not to say we're missing deadlines or shrugging off obligations—heaven forbid—but we haven't felt especially ambitious or creative. One writer said she heard it might have to do with astrological changes, another wondered if recent political tensions have zapped our energy, another said she is sensing a general melancholy in the world right now that might be touching all of us.

"All I want to do is sit around and read," I admitted, knowing full well that's not an option, but wishing for it anyway. All my friends nodded. "Yes! Me too," they said.

Then one guy who'd been kind of quiet piped up. "I don't think it's necessarily bad that we're all moving at a slower place right now," he said. "I think maybe we're just filling our tanks. You gotta do that sometimes so you can keep going."

Of course, filling our tanks! That's what we're doing. We've all been working so hard for so long, and many days we're not even sure where it's getting us. The rich are getting richer, the

poor are getting poorer, and artists are still struggling to figure out how to make a living. Still.

We've traveled a lot of miles on our respective journeys and probably been driving on fumes far longer than we should have. Maybe it's just time to refill our tanks.

"I don't see anything wrong with reading all day," my friend continued. "I mean, we're writers, we take inspiration from reading. Reading good work can be motivating."

Oh, thank you for saying that, I thought. He was right of course. There's a time to create and a time to appreciate the creations of others, the beauty *they* bring to the world. There's a time to just sit back and notice what other people can teach us and let other artists remind us why this work matters. There's a time to let other people do the driving.

I know these writers and I know myself. We'll be back up to full speed soon, speeding down our individual highways at 100 miles an hour. But sometimes you gotta hit the brakes and pull off at a rest area. Maybe keep a good book in the car, in case you wind up doing just that.

O

IN THE COMPANY OF ARTISTS

I'm a big fan of retreats for any artist or professional. Sometimes friends and I head to the mountains to get away from it all. We hunker down and work during the day (emerging now and then for snacks or lunch) and stop in time for dinner. As writers, we're usually holed up in our home offices writing, researching, promoting, and so on. But there's a special kind of creative energy that permeates the condo when we're all producing at the same time.

I know musicians and actors get this when they rehearse together. And visual artists experience it if they have shared studio space outside their homes. But writers are solitary creatures. Even if we work in coffee shops, we're usually tucked away in a quiet corner. Many writers do belong to critique groups, providing us with valuable feedback and support, but most of the time, we're on our own.

What fun it is to go on a retreat and gather at dinnertime and ask, "So, what did you work on this afternoon?" We get to hear about each other's progress or brainstorm someone's stuck story line or just commiserate over the struggles of writing. Eventually, when the wine starts flowing, our musings turn more

personal, and we sink into those conversations only fellow writers would understand.

When you leave your familiar surroundings, your senses are heightened. When you walk away from the distractions of home or office, your mind is freed. When you set a goal and share it with your fellow retreaters, you feel determined to meet it. Best of all, the chatter of other artists drowns out the voices of our inner critics.

I sometimes do writing retreats on my own, and there are benefits to that too. I typically get a ton of focused writing and reading done. Other times, though, I crave the company of fellow artists. Either way, I go home with a smile on my face, and a few thousand new words in my manuscript.

If you're serious about your art, try a retreat. Make time, find the money, overcome your hesitations, grab a friend, and go!

○

THE STUDENT BECOMES THE MASTER

When I was a writer's coach, I used to advise my clients to learn how to "read like a writer." In other words, dissect every book as you read to see what makes it work. And if you don't like a book, don't set it aside. Keep reading and ask yourself *why*? What is it that's not working? The plot? The characters? The pace? Then ask, how would you do it differently?

Inevitably, new writers counter with the same question I once asked: "But won't studying other writers on that level influence my own writing? I want to sound like myself, not someone else." We want to discover our own genius. I get that.

But think back to when you were a kid. You learned just about everything from watching someone else do it, then from mimicking their actions. If your mom or dad taught you how to make a grilled cheese sandwich, you watched first, then made it exactly as they showed you. But over time, you changed things up a bit. You cut off the crusts or added tomato. You gave it your own flair. So, even if you *do* mimic other writers to begin with, you'll eventually find your own voice.

Ah, but if I do that, they say, shouldn't I be afraid I might plagiarize other writers? I tell them, if you had to ask the ques-

tion, that proves you are aware it's a possibility and you'll work hard to make sure it doesn't happen. Most plagiarists know what they're doing. It's rarely an accident.

None of us are born knowing everything we need to know in order to do our art. We require teachers and mentors and guides throughout our journey. Don't be afraid to let other people show you what they know. And someday, they may learn something from you in return.

○

Bursts of Brilliance for a Creative Life

WHERE DO WE ENGAGE IN ART?

A writer friend asked me about my perfect place to read. My answer:

My bed: under the warmth of my down comforter reading a great novel in the soft light of my reading lamp.

My kitchen table: with my morning newspaper and a steaming cup of coffee.

My front porch: sitting in our Adirondack chair catching up on my magazines and waving to the neighbors as they walk by.

My study: in my comfy, green recliner next to the bay window with my overly cluttered bookshelves behind me.

My office: devouring the hundreds of books I use to research my World War II novels.

My bathtub: on the rare occasion I have time to soak away my worries.

My exercise bike: because reading helps the time fly.

My big, blue couch: in my family room at the end of a long day, when all I want to do is shut off my overworked mind.

I was talking to a writer friend once who explained how she uses four chairs when producing her work. One chair is where

she reads. Another is where she goes to do research. Another is at her desk where she sits to write. Another is a chair set aside just for proofing her work. As she moves locations, she triggers different parts of her creative mind.

I have a magnet on my refrigerator that says, "A room without books is like a body without a soul," a quote from Marcus Tullius Cicero. I would take this one step further and say, "A room without art is a like body without a soul." Music, literature, and art should surround us at all times.

Wherever and however we engage with art, is the best place to do it!

○

CAN BOREDOM LEAD TO BRILLIANCE?

When I was a kid, we spent many a summer day at my grandma's house while my mom worked. Though I adored my grandmother, she was not the type to entertain kids. She left that up to us. As a result, I spent many boring hours staring at the wallpaper. I also spent quite a bit of time sitting on the back of the couch watching the world wander past my grandmother's big bay window.

And in time, I noticed something interesting. During the lunch hour, the lawyers and statesmen who worked a block away at the state capitol building would walk past my grandmother's house, deep in conversation. And the doctors and nurses who worked at the hospital half a block the other direction would also hurry past. If I were to put up a lemonade stand at exactly that time, these successful individuals would have to walk right past it. And as statesmen and healers, they were practically obligated to support some cute little kid's endeavor, right?

So, I had my mom buy us cans of lemonade, and my brother and I mixed up a few pitchers. We positioned our table as close to the sidewalk as possible, with our backs to the street, so that our sole focus would be on those passing professionals. We

spoke up, we smiled, we waved, and we sold lemonade. At the end of the lunch hour, we packed it up and went in. It was too hot to sit out there waiting for the occasional passerby. We'd be back tomorrow when the traffic was high.

Some people look to this story as proof I've always had an entrepreneurial bent, but I see something else. In my mind, it all started with boredom, which led to observation, which led to distinguishing a pattern, which led to inspiration.

Is it possible that in order to do our best work, we must build in some time to just sit with our thoughts? Is it possible being busy doesn't always equal being productive? Can we give ourselves permission once in a while to just sit and watch the world go by? And if we do, what might we see?

HOW NOT TO OFFEND

I once had the pleasure of hearing Kevin Kallaugher, the political cartoonist for *The Economist* magazine, speak. You don't meet political cartoonists every day—there are actually very few of them—so I was eager to hear what types of questions people would ask during the Q&A.

One gentleman asked "Kal" how he handled taboo subjects in his art, like gun control, abortion, religion, and so on. He told us, while it's tempting at times, he opts not to offend. He said the point of political cartoons is to engage the reader and make them think. If you automatically offend someone, say by drawing a ridiculing picture of a prophet, their anger will keep them from considering your point.

As artists we face this dilemma often. Can we depict a controversial topic in our art, can we show a beloved figure in a less-than-flattering light, can we cross the lines of "decency"? And if we do, will we be admired for our courage or hated for our disrespect? Akin to Kal's comments, will our decisions prove more distracting than useful? I call that "pulling us out of the story."

For example, I once saw a production of *Les Miserables,* my favorite musical. In the number "Master of the House," which takes place in a bawdy inn, the innkeeper sings as he picks the pockets of guests or sidles away with their belongings. But in this staging, our gaze was drawn to a couple in the background who were simulating sex in an upstairs bedroom. All eyes were on them, hence most viewers missed the misdeeds of the innkeeper, which was the point of the scene. Was the shock factor worth the distraction?

Art, like so many things, is subjective. What is offensive to me, may not be to you. What is funny to me, may be distasteful to you. Even if an artist tries to walk the politically correct path, he or she will likely sometimes stumble.

To me, it all comes down to the purpose and intention of the art. If you are purposefully pushing the boundaries in order to challenge or shed new light on them, that's one thing, even if we don't agree with you. If you're seeking to shock or offend simply to garner attention for yourself or your work, that is another thing. And most of the time, your audience can tell the difference.

○

MULTICULTURALISM IN THE ARTS

This question gets asked a lot: Does anyone have the right to tell stories outside of their race or culture? I have friends, for example, whose story ideas have lately been turned down because they wanted to write about a race different than their own.

I write a multicultural children's series set in World War II called the Home-Front Heroes, and from the moment I conceived of the series, I knew I'd be writing about different ethnic groups. Why? Because to tell the American story during one of the most critical times in our history, it's impossible to view it through the lens of just one city or neighborhood. In the 1940s it was rare for people to travel more than 50 miles from their homes. Your city, your neighborhood, and the people who surrounded you *were* your experience with the world. In many ways, that's still true today.

In my first book, my female character is white and living in rural Illinois. In the second, he is Japanese American living in an internment camp. In the third, he's Mexican American living in San Antonio. In the fourth, she's Jewish and living in the

Bronx. And in the fifth, she's a military brat living in Hawaii. As a writer I had many concerns when starting these books:

- I did not live in the 1940s, so I'd have to gain knowledge about that time period.

- I did not grow up a young boy, so I'd have to talk to some of my male friends, my husband, and my son to see how young boys think.

- I did not grow up in a small town (like my Illinois character) or a big city (like my children in the Bronx or San Antonio).

- I did not grow up Japanese American or Jewish or Hawaiian, and even though I am half Mexican, I did not grow up strongly in that culture either.

I knew from the outset this series would require not only deep research but also real empathy. I'd have to listen very carefully to the people I interviewed about their experiences and hold space in my head and heart for their truths, as they were told to me.

All writers write outside of our experience, even memoirists, because even though you lived it, once you cross that line and tell us what your mother said and how she said it, you're bringing your own interpretation to her experience. What I know full well as a historian is there is no such thing as absolute truth or even absolute fact. There is only how we interpret it, and our intention when we do so.

Bursts of Brilliance for a Creative Life

I've written numerous stories about men and women from various backgrounds, and I never take that responsibility lightly. I admit to having felt apprehension when my World War II story about the African American WAC (Women's Army Corps) was published in my book, *Dancing in Combat Boots*. I wrote that story in dialect, because that's how the woman I interviewed talked. To be honest, I couldn't have written it any other way if I tried. I worried when it came out, though, I'd be criticized for that choice.

But my source called me when she received the book. She was thrilled. "And thank you for making me sound black," she said. "Because now anyone who reads this story will know immediately this was *my* people this happened to." Whether you agree with my decision or not, all that mattered to me was that I'd done right by the woman whose story I told. I had captured *her* truth.

In other words, as one writer put it, there has to be a "why." If there's a good reason for you to write that character, do it. But if you're throwing in a multicultural character just because, refrain.

As artists of all kinds, though, I believe we have a duty, a responsibility, to tell the stories that need to be told, especially now. Now is not the time to suppress a story simply because you're not sure you're "allowed" to write it. Now, more than ever, we need diverse stories and perspectives, and we need

people who will tell them with respect and empathy. If you can do that, then embrace your art!

○

DOES YOUR GENDER INHIBIT YOUR ART?

Recently, I was interviewed for *Veteran Voices: The Oral History Podcast*. The show features people who tell veteran stories in creative and interesting ways, including oral historians, authors, poets, playwrights, videographers, photographers, and the like. The host, Kevin Farkas, invited me to talk about my World War II novels, all of which are based on real people I've interviewed.

Before we recorded the podcast, Kevin asked me an interesting question. Given that my first book is based on interviews with male civilian construction workers who were taken prisoner by the Japanese, he asked whether I thought my being a woman had affected the interviews in any way.

It's a fair question. After all, I was in my early 20s when I conducted those interviews, naïve, and very feminine. And these men were talking about torture, injury, illness, and death. Did my age or gender cause them to hold back? I didn't get that impression at the time, but I did notice they'd often apologize for cussing or would preface their comments by saying, "Now this is a little rough" or "You sure you want to hear this?" Would they have said that to a man? Maybe. I'm not sure.

Because I behaved in a professional manner, because my questions were well thought out, because I showed sincere interest in their stories, and because I treated them with respect, I don't think they held back much.

But I wonder now how often gender does affect our art. Certainly sexual harassment has been, and continues to be, a problem for female artists and professionals going way back. Think of the female artists and writers who had to release their work under their husbands' names to gain acceptance, or the ways women were excluded from certain arts organizations or denied prominent awards, or the ways they were expected to perform sexual favors in order to advance. But think also about how women were kept out of places or conversations where they could explore their art because those environments weren't considered "ladylike."

But what about men? Does their gender ever inhibit them? Were women they interviewed while writing their books or plays as forthcoming with them as they would have been with a female interviewer? Does a male photographer have to change his demeanor in order to make his female subjects feel more secure or, conversely, less inhibited? Do men ever adjust their art out of fear it might offend women?

I'll go out on a limb to say my female artist friends do seem to struggle more to get their work done. That's one difference that is real. We still live in a world where women are expected to deal with most of the household and child concerns, are

mostly responsible for aging parents, and do the bulk of the volunteer work in our communities.

This is a conversation that could go on and on and has so many layers. It's a conversation I hope we continue to have. The more we understand each other and our unique challenges, the better we can support one another in the making of great and true art. And to me, that's what it's all about.

O

FROM SETBACKS TO SUCCESS

When I was in the fifth grade, my teacher gave us an assignment to write a poem. For some reason, that poem really mattered to me. I *had* to get it right. I stayed up past my bedtime, and my mother ordered me to bed. "Just a little longer, Mom. I have to get this poem right." I'd never felt that way about an assignment before.

A day or two later, my teacher, Mrs. Irons, called me up in front of the entire class and said, "You did not write this poem. No fifth-grade student could write a poem this good. You must have copied it out of a book. Now go home and write your own poem or you're not getting a grade."

I slunk red-faced back to my chair. I could hear kids laughing, and one boy said, "You cheated." I did not cheat! I sat at my desk fighting back tears of humiliation and anger, and then slowly something dawned on me. I lost focus on what was happening around me because all I could hear was a voice in my head that kept saying, "Wow, you must be a really good writer."

And that was it. From a moment of pain and frustration came a new direction for my life. I had found something I not only loved and cared about but was good at.

There have been many more moments like that one, moments where something good came from bad, like the time my agent told me to give up on my book, *Dancing in Combat Boots*, prompting me to rewrite the book for the better. Or the time I fired my fourth and last agent and then turned to self-publishing, which became my career. Or the time I had to give up my office because the overhead was just too high, and that saved income helped me reorganize my business.

This artist's journey, like any journey, is accompanied by its share of heartbreak and tears. Even my most fortunate and successful artist friends experience their share of disappointment and frustration. In our darkest moments, we have choices. We can give up or we can trust this newest setback is not a roadblock, it's just a chance to change directions.

○

DO GOOD PROBLEMS REALLY EXIST?

Once, I was meeting with a friend who was dealing with a series of misfortunes. We talked about her a while and how I could help. Then she asked about me. "I feel bad talking about my silly problems considering what you're going through," I said. Her answer was one of the most selfless and empathetic comments I've ever heard. "I don't think of it that way," she said. "It's not a competition. Your problems are as real to you as mine are to me."

But you've noticed, I'm sure, not everyone is as generous with their sympathy and understanding. Let's say, for example, you're an artist excited about two promising new projects, but you fear working on both is splitting your focus. "Oh, you poor thing," your friend says. "At least you *have* two projects."

I know our culture today presses us to always look on the bright side, and it's good advice in general, but comments like, "Sounds like a good problem to have," can feel so dismissive at times. A problem is a problem, no matter how good. For artists especially, support is sometimes hard to come by. We're told, "Well, you chose to be an artist," or "Yeah, but you get to do what you love all day," or "I wish I had *your* problems." If we

complain too much, people will actually say, "Well, maybe you need to look for a real job." So, we tend to keep our troubles to ourselves or to joke about them, as if they don't matter. But they do.

I think we'd all be better off if we sometimes set the positive platitudes aside and remembered that sometimes people just need to vent and sometimes they need some actual advice and sometimes they just need a pat on the back. But mostly, we just need to be heard.

○

Bursts of Brilliance for a Creative Life

IF I HAD A MILLION DOLLARS

- I'd pay for ads for my books to appear on the side of every bus in five major cities.

- I'd hire a really good publicist at the going rate of $3,000 per month and have them promote the heck out of my books, blog, and speaking.

- I'd pay for endcaps for my books in every independent bookstore that would carry them.

- I'd donate library sets of my children's books to every elementary school in the country.

- I'd hire out all my marketing and spend my days just living the writing life.

But I don't have a million dollars, so I guess I'll keep doing all those inexpensive things every working artist does in the hopes that you'll discover and buy my art.

- I'll keep up an active social media presence.

- I'll fight with the templates every month to produce a good newsletter.

- I'll speak for low-fee at writers' conferences and events to share my knowledge.

- I'll do radio and TV spots in the hopes you will "see me everywhere."

- I'll keep a box of books in my car in case I run into someone who might want one.

It's hard not to envy people with big budgets who can pay to get past the "noise" so people can hear about their work, but for most of us, it's about striving day in and day out to make connections with people who just might want or need the work we produce. And that might happen in a grocery store line or a doctor's office or through an unexpected e-mail. And when it does, it's breathtaking! I wouldn't trade that for an impersonal TV spot on the *Today Show*. Oh, who am I kidding, of course I would. In the meantime, though, I'll see you in the book signing line, and I'll be happy to shake your hand.

○

GEORGE CLOONEY GETS IT RIGHT

George Clooney won a lifetime achievement award at the Golden Globe Awards in 2015. In an effort to cheer up the nominees who had not won in their categories, he reminded them no one remembers how many awards an actor collects, what they remember is the iconic role he created or the famous line she uttered. And he's so right. Most of us can't even recall who won best actor just one year ago.

To be honest, I don't remember what I said at my first awards ceremony, when my novel, *Remember Wake,* won second place. But I'll never forget what happened *after* the ceremony. This lady came running up to me. "I was one of the judges," she said. "And I lobbied hard for your book. I'll never forget your story, and to my way of thinking, it was the best of the bunch."

It sounds cliché, but in that moment, I did feel like a winner, and I left with a new understanding that changed me forever. An award is subjective. It's totally up to the whims, the prejudices, even the qualifications of the judges.

What means far more to me than the trophies and plaques I've been lucky to earn are the compliments I've received: The people who've told me they stayed up half the night reading

my novel. The ones who gave *Dancing in Combat Boots* to their mothers to prompt them to share their own wartime stories. The father who e-mailed to tell me he could hardly get his son to read, until he gave him *V for Victory*. "I had to pry away my Kindle from him," he told me.

Have you ever been standing in a grocery store line and had someone say to you, "I saw your performance last weekend. You made me cry." Or, "I bought one of your paintings. It's the first thing everyone comments on when they enter my house." Or, "I played your song over and over after my boyfriend and I broke up. You got me through it."

If you have, then trust me: you are a winner! And if you haven't, set your sights on *that* goal. In the end, those sentiments will bring you far more comfort and encouragement than any winning certificate ever could.

O

DON'T WASTE YOUR LUCK

I had a bit of financial luck recently, which has given me the ability to pull back on some of my paid work for a while and focus on my writing again. While I'm wildly excited by that prospect, it's harder to do than it sounds.

For most artists, there is no such thing as financial security, and our incomes fluctuate dramatically at times. We get used to doing what we have to in order to pay the bills, and when something comes along to allow us the space and freedom to spend more time on our art, we feel conflicted.

We feel guilty that we are "just" working on our art. We feel insecure about whether the good times will last. We worry other people will think we're spoiled artists who simply dabble in our "hobbies" all day.

And it's hard to let go of the sense of responsibility and worth that comes with earning steady money. It's hard to focus on our art when we keep thinking we should be spending that time on something that would bring more cash our way.

But, I don't want to waste this luck. I don't want to take this gift for granted. Life goes in stages, and for this stage, I want

to buckle down and complete some writing projects that have been left undone for far too long. There is value in those projects that can't be measured by dollar signs.

If my luck reverses, I'll stir up more paid work. Until then, you'll find me in my office plotting and writing stories I hope will inform and inspire, and penning essays to help illuminate life in the 21st century.

In the end, when I am long gone and the money I made is spent, those writings will live on. If you get some good luck, don't waste it. Spend it on your art. If it hasn't arrived yet, ask for it. You may be surprised what a little faith can accomplish.

○

YOU WANNA KNOW WHAT'S
REALLY GOOD FOR YOU?

We are bombarded daily with tips for how to live longer, healthier lives. How to treat our bodies better, bolster our minds, and nourish our souls. We're supposed to drink eight glasses of water a day, get eight hours of sleep per night, eat our greens, meditate, take time for ourselves. Blah, blah, blah.

I'll tell you what's really good for you. This:

Potato chips and chocolate are good for you. If you've been beating your head against the wall for hours trying to get that paragraph just right or learn that new song on the guitar or achieve the right lighting for that photograph, you need a pick-me-up. And, no, I don't mean a stalk of celery, I mean something salty or sweet. Something decadent, because making art is hard work, and we deserve a treat.

Missing sleep is good for you. But only if you're missing it because you can't stop thinking about that story or reworking that painting or messing with that tune. We can't control when inspiration strikes, so if it hits in the middle of the night, and it feels good, do it!

Caffeine is good for you. If you were up half the night creating, you need that cup of coffee. If you've got a deadline and you've hit that four o'clock brain drain, you need that Mountain Dew. If your artist friend calls at nine o'clock in the evening needing to vent, go ahead and make that cup of Earl Grey tea. You might be up for a while.

Bragging is good for you. When that stupid-ass piece of art finally comes together, you gotta tell someone. Sure, you could do the "right" thing and modestly state, "I finished my piece today." Or you can declare, "I'm done! And it's awesome. And I'm a goddamn genius." Now doesn't that feel better?

Alcohol is good for you. There's a reason we have the expression, "I need a drink." Sometimes, you just do. And I think artists need it more than most people. Why? Because we're responsible for all aspects of our work and creation, and that can be overwhelming at times. Of course, if you can't drink, you can always have more chocolate. That works for me too.

This is not permission to lead a destructive life. If you don't take care of your mind and body, you can't do your best work. But sometimes, your creative soul knows better than the experts what is really good for you.

○

Bursts of Brilliance for a Creative Life

MAGIC IN THE MESS

In the eighth grade, I was disappointed to get a certain English teacher. He had a reputation for being boring and dismissive and not too bright (although I'm sure eighth graders had harsher terms for him). And he proved to be all of those things. But halfway through the year, he gave us an assignment that excited me. He told us to write down the lyrics to a song that meant something to us and then break down the song in an essay and explain why we loved it.

I chose "The Gambler" by Kenny Rogers. (I know, odd choice, right? But I was an odd kid.) I put a lot of thought into every line of the song, analyzing it in writing to the best of my ability. I think I talked about how sometimes the answers come from the most unexpected places, and how you had to know when to stand your ground and when to quit, and how the Gambler spoke these amazing words of wisdom as his last act on earth. He passed on his wisdom, then he passed away. I was terribly clever and mature and worldly, I thought. And I turned it in fully expecting an A and a comment from my teacher about how insightful I was and how he'd never hear that song again without being touched by my analysis.

When I got the paper back, there was a big red B at the top. I'd gotten an automatic grade decrease, he said, because I'd neglected to put the title of the song in the upper left-hand corner of the page as instructed. I was furious. Such an arbitrary rule had cost me my A. Such a meaningless thing to grade me down for in the face of such a thoughtful essay. Life and all its silly little rules were stupid. Why couldn't people ever see the bigger picture?

As an adult, I still wonder that sometimes. You put out a piece of writing that you hope will inspire and impress everyone who reads it, then you get an e-mail that says simply, "There's a typo in your second paragraph." Or you mount this amazing photograph that took you three years to finally capture, and someone comments on the nick in the frame. You work hard at your art, you put your heart and soul into it, you feed it with your genius, and all people see is what's missing. It's frustrating. School was often frustrating because the administrators so often seemed to care more about whether you raised your hand before you shouted out your brilliant observation than they did about the observation. And teachers so often asked for our opinions just so they could tell us we were wrong.

Of course, rules are important. And structure is important. And guidelines are important. But creating is often messy and it doesn't follow the rules and it doesn't push the chair back in place when it's done.

Bursts of Brilliance for a Creative Life

So, now that I'm a supposedly much wiser adult, what do I do? Sometimes I allow myself to create with abandon. The rules, the expectations, the judgments go out the window. When I'm done, I happily roll around in the mess I made. Then I take a deep breath and go back. I make sure I've crossed my *t*'s and dotted my *i*'s and I reread the rules for submissions. I make sure everything is in order. I confess it's not always possible to just feel free. After 26 years in this business, the rules are ingrained. But it sure feels good to once in a while stray from the path and just go exploring.

And always when I put something out in the world, I trust. I trust that though I've wrapped my package up in a neat and tidy bow, when readers open it, the magic in the mess will come spilling out.

P.S. Don't stop telling me when you see a typo. I do appreciate the chance to fix them.

BIRTHING YOUR CREATIVE BABY

I was visiting with a group of writers, one of whom had finished a second major revision of her book and was about to start a third. "It's like birthing a baby, isn't it?" one of the other writers said. "Yeah, a breech baby," my friend responded.

There's *nothing* quick or easy about writing a book. The writers who make it look easy likely worked much harder and longer than most people will ever realize. And those who brag about how quickly they produced a certain work don't always tell the whole story. "I wrote my book in thirty days," they say. What they don't tell you is that for those 30 days, writing was practically *all* they did. And they don't often count the time they spent in revision after their 30-day baby was reviewed by a trusted reader or editor.

"Anything worth doing is worth doing well," the old adage goes. I keep it at heart whenever I start a new project, but it's not always easy. As the very long process of researching, writing, producing, and promoting a book unfolds, it's often tempting to cut corners.

But just as any good mother does her best to nurture the child in her womb, bring him safely into the world, and raise him well, any good artist does his or her best to bring art into existence that we hope adds something of value to the human experience.

So, to all you artists out their toiling long and hard on your new works, know that we appreciate your efforts. Your babies are beautiful!

○

PART III

Because You're Worth It

THE AGE OF THE ARTIST-ENTREPRENEUR

I read a very interesting article recently on *The Atlantic* website about the evolution of the "artist." We started out as craftsmen or artisans, back in the times of Shakespeare and Bach. We were apprenticed to master artists, we were middle to lower class, we were selling our wares.

We then moved into the period of artist as genius (albeit often a starving genius). After World War II, we institutionalized the arts, and the "professional artist" was born. Now, with the rise of independent labels and publishing and the influence of the internet, we are entering the age of the artist as entrepreneur.

In fact, the author of this article, William Deresiewicz, argues that "the artist" may soon be dead, replaced by "the creative," because after all, anyone can now create, and we are *all* encouraged to discover our "art," whether that is writing computer code or building new widgets or discovering a cure to cancer.

This could explain why there's so much confusion right now. We're talking about a seismic shift in how the arts "work" and how we see ourselves. And I feel like I was one of the first to ride the cusp of the shift from professional artist to artist-

entrepreneur back when I self-published my first novel in 2002 and then as I went on to build my business.

I'll admit part of me has greatly enjoyed shaking up the status quo, breaking the rules, pushing the boundaries, trying new things. But another part oftentimes feels frustrated, confused, and unsure. And for every project I've launched that succeeded, there have been those that failed.

"You can't fight progress," as the old saying goes. And I embrace that, but there are some days I wish the old rules were still in place. It's all well and good that anyone can be an artist now, but how do we single-handedly find our audiences and how do we resist the temptation to make art just to suit the marketplace, and not because it's the art we're called to create?

Those are the questions we will continue to explore as our world keeps on changing.

○

IS HOPE A STRATEGY?

The other day, I was explaining a hope I had for my business as I was opening a stack of mail. My well-meaning-but-wet-blanket husband repeated his favorite quote, "Hope is not a strategy."

At that moment, I opened an envelope that contained a check from a person I'd reached out to with a business proposition. I had not heard back from her but had been *hoping* she would sign on.

"Ah, ha," I shouted. "See this? Hope is *too* a strategy."

What my husband means, of course, is you can't just put your art out there in the world and hope people will find it and buy it. Just because you build it, doesn't mean they'll come. To succeed, you need plans and strategies. And to create those you need to do research and identify your competitors. You need good branding and messaging. And you can't always do it alone. Sometimes you need to hire people to help you build a better website or create better sales language or teach you how to manage your social media. You need to embrace marketing and promotion so people find you in the first place.

But my husband is also wrong that hope is not part of your strategy. You can't tell me Steve Jobs or Bill Gates has never uttered the words, "I hope this new product flies." Or that Adele never thought, "I hope people like my new album." Or that some Broadway actor has never said, "I hope I win a Tony someday."

No matter what your passion or profession, you gotta hope your work will connect with the right people. In fact, I'd argue that without hope, none of us would ever start a new project. If you think of it that way, hope is the very first part of any strategy.

○

ART FROM THE HEART

I have two necklaces I count among my favorites. Every time I wear each of them, I'm guaranteed a compliment. One was made by a local artist I met at a craft show. I've bought several pieces from her over the years. The other I purchased at Macy's department store. It's from the *1928 Jewelry* line and was made by some unknown artist. Interesting to think he or she will never learn how much pleasure his or her creation has given me.

And that's the thing about art: we sometimes roll out our big, fancy projects in the hopes of getting recognition or fame or at least appreciation. And sometimes it *is* our signature work that brings us the most attention. But along the way, we are constantly creating other pieces without knowing what impact they have on our audiences.

I think of the countless newsletter articles I've written, for example, any one of which might have helped launch a career. Or comments I've received from readers of my blog telling me that my words were exactly what they needed to hear. I had hoped my books would be my legacy, but I sometimes wonder if I might not be better remembered for my clever Christmas letters.

I once asked my friend who ghost writes books how she could stand not getting public recognition for her brilliant words. She told me that's not what she was hired for. She was hired to make the expert she was writing for look brilliant. And she did. He got the credit, but the art was all her. And the satisfaction of a job well done.

When Sam Smith won his Grammy Award, he said, "Before I made this record, I was doing everything to try and get my music heard. I tried to lose weight and I was making awful music. It was only until I started to be myself that the music started to flow and people started to listen."

My point is, we never know which of our works will strike a chord and with whom. That's why we must always put our best effort into everything we do and find a way to feel passionate about it all, even those work-for-hire jobs that will never carry our names. Because the best art is created from the heart. And ego doesn't reside in the heart. Neither does your pocketbook.

ARE YOU PRODUCING OR CREATING?

A friend once told me she had lost interest in a particular artistic endeavor to which she'd committed herself. She said it no longer felt like she was "creating," only "producing."

What an interesting distinction. We hear it said all the time that certain artists are "producing at a high level" or that good artists should be "producing work all the time." There's a lot of language thrown our way that has to do with production, a word whose base is formed from the word "product." But when we are producing our best art, it doesn't feel like production at all. It feels like creation.

It feels like giving birth, the ultimate act of creation. It feels like something bigger than us is flowing through us, a divine creation. It feels like this is exactly what we were meant to do, a bit of self-creation. It feels like we've been touched with unexplained power, a supernatural creation.

It doesn't feel that way all the time. And often it doesn't feel that way for long. But it's the thrill of creation that keeps us coming back, whether we're doing it on our own or with a team.

Creation feels new, original, and untapped. Production feels old, predictable, and routine. It's not to say production is a bad thing. Without it, we wouldn't have cars to drive or cereal to eat. Production can still produce great things. And sometimes it's necessary (like my friend with her contract).

But creation is where the true art lies. Creation leads to growth. It stimulates our sense of wonder. It brings us wisdom while keeping us young. Whenever possible, go there.

○

TO BOAST OR NOT TO BOAST

If you look up the words *confidence* and *arrogance*, you'll find there's a fine line between the two. The former means having self-assurance in one's own abilities or qualities. The latter implies an offensive display of superiority or possession of an overbearing pride. But where's the line between self-assurance and overbearing pride? And who decides?

As artists, we face a unique conundrum. People expect us to be confident in our work, yet not boastful. We're often told in the early stages of our careers that we don't "sell" ourselves enough—that we need to toot our own horns, sing our own praises, get out there and *make* people believe we are good.

Then when we start to experience some success, we're told the opposite. "Don't share too much about how well you're doing. It only makes people feel bad and makes you seem arrogant." We feel pressured to downplay our achievements, even in our moments of greatest success. Humility, even if it's not sincere, is demanded.

Unless, of course, we're geniuses. As a society, we expect, maybe even want, our genius artists to be boastful and arrogant, so long as they do so in a manner that is eccentric or colorful.

Then we can shake our heads and say, "Well he can't help it, you see. He's a *true* artist."

In a sense, I'm not sure whether we can ever censor ourselves enough to know when we've crossed the line. Like so many things, it comes down to subjectivity. I once had a friend ask me if I was afraid of seeming boastful if I announced my new award. Another friend, though, once told me, "You don't brag enough. You need to let everyone know all the things you've accomplished."

So, once again, it comes down to being true to yourself, and leaving the judgment to others. If you're proud of something, if sharing it makes you happy, if you hope it will make others happy too, for heaven's sake, say it. Give us a chance to share in your excitement. Just remember that a little boasting goes a long way.

○

THE SWINGING PENDULUM OF ART AND LIFE

According to the theory of pendulum effect, trends in culture, politics, and history swing to one direction until they reach a tipping point (usually driven by popular mood) and then swing back. This makes living in a two-party democracy like ours challenging at times. A Democratic candidate may gain the presidency for four to eight years, and then oftentimes the pendulum swings toward a Republican candidate, and then back again. In most cases, the new president will spend at least a portion of his or her time undoing what the previous president did!

As frustrating as this sometimes feels, the reality is that progress *does* get made. We did finally achieve the vote for women and African Americans, for example.

I read once of a pendulum theory regarding the visual arts too. How it swings back and forth between line and composition and color as the supreme value. Maybe my writer or musician friends know of a similar comparison in literature or music.

I've even read this theory applied to sales. If the salesperson's pendulum swings too much toward prospect meetings, they

don't have time to close deals. If it swings too much toward closing deals, their prospects dry up.

I think, as artists, we do this in another way too. We swing between making art for art's sake and making art for money's sake. We may even swing in our artistic themes or belief systems.

The point is, if you stay in this business long enough, eventually the things that matter most will stick. And you'll have a diverse body of work that will tell a story, your story, that will last even as the pendulum swings by again.

●

WHY YOU SHOULD IGNORE THEIR PAIN POINTS

As an author and business owner, I've attended many a class and read many a book on sales and marketing. So often I'm told the first step in selling your products or services is to identify your buyer's pain point then explain how your product or service is the solution to that pain.

Every time I hear this advice, I bristle. I once asked, "What if my customers don't have a pain point?" (I was thinking that really the people who bought my novels were just looking for a good read.) "Then you convince them they *do* have a pain," I was told. "They just don't know it yet."

Okay, I thought, then your pain (though you don't know it) is you're tired of reading so-so fiction and dismayed that you don't know enough about your own country's history; therefore, you *need* my World War II novels. No, I'm serious, if you don't buy my books, you're going to regret the time you've wasted slogging through those mediocre stories, and you're going to feel more and more inadequate because you don't know your history. My books are going to save you, especially given current events in the world. Convinced? Good...click to my products page or hop over to Amazon and buy, buy, buy.

To be honest, I resent how advertisers take advantage of us. I resent that the sale is, so often, the only goal. I think it's true many people *are* selling products that actually do meet a need, and I'm grateful for those products, but art is about more than feeding a need. Art is about the artist's first examining his or her own pain points—what we need to understand about ourselves or our world right now—and then creating art to reflect that inner journey in the hopes fellow journeyers will recognize themselves in the piece and a connection will be made. A true connection, not one born of manipulation.

I've been told I'll never be a best seller because I can't embrace this notion of selling to your pain, and they're most likely right, but I'm okay with that. Some of my happiest moments are when people tell me, "I knew nothing about World War II and didn't know if I'd like your book, but I loved it. Now I want to know more." In reading my story, they didn't go looking for a solution to a problem, they took a chance on something new, something unfamiliar. They didn't find a remedy that could provide rest and relief, they found the opposite—a pinprick that awakened in them questions and curiosity. Or maybe they just found a few hours of enjoyment. And what's wrong with that?

◉

DOES THE WHOLE WORLD THINK LIKE YOU?

One year, we'd had an unusually cool and rainy summer in Colorado. A friend was complaining about the weather, fully expecting me to agree with her, as I'm sure most people had. "Oh, I've loved this summer," I said. "I hate being hot, plus I've hardly had to water." She stared at me in disbelief.

This is a silly example of a much larger point. We should never assume everyone thinks the way we do, even if our thinking seems to reflect the norm. There will always be those outliers, rebels, even malcontents who disagree with the majority. Sometimes, though, this silent minority can wind up being even more passionate about their opinions *because* they are different. And some of those people will be your most ardent fans and followers.

When marketing our products, our minds go toward the most obvious connections. And that's not a bad place to start, but can you then turn things inside out? Can you think of the people who would not normally be asked to pay attention to your type of offerings? If you can reach them in a way that appeals to their way of thinking, you might just be the only artist of your kind who has ever approached them. If you can make

them feel noticed and appreciated, they might just buy your work because you didn't assume they wouldn't.

Notice, though, I said reach them in a way that appeals to *them*. This is not about your trying to convince, enlighten, or educate them. It's about inviting them to see something in your art that matches their unique worldview. Maybe it's changing the color of something in a way we wouldn't expect or writing a character who could easily be stereotypical but is not. Your attempts won't always work, but it'll be pretty dang satisfying when they do.

○

DOES YOUR ART PASS THE RELEVANCY TEST?

How often do we, as serious artists, insist on creating work for which there is no real market because we feel there *should* be? I talk to writers all the time, for example, who tell me a premise for a book I doubt will ever sell. When I try to point that out, they say, "Well, I don't care. This is what I *want* to write." And if it's true—if they truly don't care if it sells or not—I tell them to go for it. But half the time, they don't really mean that. What they mean is they know I'm right, but they hope I'm wrong. They hope something miraculous will happen and the book will take off anyway.

I see this attitude in all of my artist friends when they hold on to old ways of doing things because they can't accept those days are over. Or when they declare loudly and strongly that even though people don't care about that type of art right now, they *should*, as if they can somehow *make* people care. I see it when they take the idealistic approach and say things like, "I'm just going to think positive thoughts and visualize strong sales and trust that people will find me." I see it when artists focus on gimmicks to get people to buy, which sometimes works to gain attention but doesn't usually result in the kinds of reviews or endorsements that can carry the art further.

This is perhaps the hardest conversation we can have with ourselves about our art if sales are important. Am I producing this piece just for me? Is it all about what I want? Or am I also producing it for my audience, because it is what *they* want and need? That's not to say we should "sell out" as artists and just try to follow the trends. We should absolutely produce some work because we want to or because we feel it's important. But when it comes to running our businesses, we need to think like business owners and make sure we're also giving our customers what is relevant to them.

○

YOU'RE ONLY A STARVING ARTIST
IF YOU CHOOSE TO BE

I often find myself reassuring friends whose children want to go into the arts that their kids won't starve, nor will they ask for support for the rest of their lives. I know dozens of artists—writers, singers, filmmakers, visual artists, actors—and none of them are starving. Few of them ask their parents for money, either, just as I never have. On the flip side, I do know successful business owners who borrowed cash from their relatives to get started, but no one seems to look sideways at that.

It's true any serious artist would rather focus on his or her art full-time. It's during the times when we are free to explore our art with no other obligations that we learn and develop and grow. It's when we do our best, most demanding, most inspired work.

Partly due to that, there are times in our careers when we artists may *choose* to sleep on a friend's couch so we can spend more time in our studios. Or survive on ramen noodles in order to practice our music all day. Or sell our cars to finance a few months off to write. We don't do this because we're lazy or spoiled or "Bohemian." We do it because we *know* that in order to get better at our art, we must sometimes live it.

At other times, we must work. Actors teach classes, writers take on freelance work, filmmakers do projects for advertising agencies. Many of us have day jobs, some work part-time, some pick up odd jobs depending on how much money they need or want at that time.

Just because many of us are not bucking for the highest paycheck doesn't mean we're not ambitious. Quite the opposite. We're willing and happy to forgo many of life's luxuries in order to be the best at what matters most, our art.

If you meet a starving artist, know that it's a choice.

O

ARE YOU WORTH MORE THAN
A DOLLAR AN HOUR?

As a teen, I was such a good babysitter I got regular calls from nine different families! I thought it was because I was always available, played well with the kids, and cleaned up the messes. Now, I think it was also because I was the bargain of the century. At a dollar an hour, I was a steal! Granted, this was the early '80s, and none of my friends were making more than two to three dollars an hour to sit, but I couldn't even bring myself to charge that!

You could argue the people who hired me could've done the right thing and offered to pay me more, but really, the responsibility was mine. And I think a lot of artists will relate to my reasons for not wanting to raise my rate.

(1) I was afraid I'd lose those jobs. (2) I was worried if I asked for more, they'd see me as greedy. (3) I thought I was doing them a kindness, that by keeping my rates low, I was enabling them to get out and enjoy themselves. (4) I felt like I was just a kid, and probably didn't deserve more money anyway.

Are you still writing articles for no pay thinking you "need" the byline? Are you jumping in to offer a discount on your

painting before you've given the buyer a chance to pay full price? Are you keeping your fees low because you believe art should be accessible to all? Because if you aren't valuing the work you do, why should I?

I'll be happy to pay you less, especially if you seem to appreciate it. If you tell me it's "not your best work," I'll take you at your word. What do I know? If you tell me, though, this piece took you 30 hours to complete and you're proud of it, I'm going to feel like whatever I'm paying is probably not enough. Don't be afraid to show off your effort. Don't be afraid to tell me you're good and your rate reflects that.

In the past 25 years, the theaters I frequent have doubled their ticket prices. And I'm still going. So are other patrons. In fact, one of the theaters is busier than I've ever seen it. Why? Because they've proven to us their product is worth it. They don't have to prove it anymore.

Is your work worth it? If not, when will it be?

○

Bursts of Brilliance for a Creative Life

BLESSINGS FOR A WORKAHOLIC

When we were newly married, my husband took a job at a Fortune 500 company and stepped quickly onto the fast track. I made him promise he'd never let his work interfere with our home life, that he'd never become a workaholic. And he hasn't. Ironically, I'm the one who now fits that description. Lately I work nights and days and weekends. And when I'm not working, I'm mostly thinking about work, dreaming about it, obsessing over it. Sounds terrible, right? Actually, it's not so bad. Why? Because my work excites me. All of it! It also frustrates and annoys and baffles me sometimes, but that's part of what makes it so intriguing.

That's not to say I'm not concerned about my workaholic tendencies. Thirteen hours of sitting at a desk can wreak havoc on the body, for example, so I exercise every day, and I never work through lunch. No matter how busy or distracted I am, I take time to eat right. Long work days also put a strain on relationships. I make sure I'm at the dinner table with my family every night, and I plan time each week to spend with my husband and kids.

And even though I love my work, I also love my downtime. When I need to rest my brain, I shut off all technology and watch a movie, read a book, or practice yoga. I never take my computer on vacation. Never. Whatever it is, it can wait two weeks until I get home.

As a creative, I know sometimes we need to get away from our work in order to gain new perspective, so I seek out new activities each month or reach out to meet new people. We can't expect any one thing, not even our work, to fill every aspect of our lives.

I was one of those kids who never knew for sure what she wanted to be when she grew up. That lasted into my mid-20s. The two things I knew for sure, though, were that I wanted my work to have meaning and I never wanted to be bored. I can't remember the last time I looked at a clock and wished the hands would move faster. Now I wish I had a few more hours in the day. For me, that's a blessing.

○

THE HARDEST EASY JOB

I attended a National Speakers Association convention and heard a presenter refer to speaking as one of the "hardest 'easy' jobs there is." Made us all laugh.

A friend of mine recently sought a speaker for a 30-minute keynote to kick off her event. When he quoted her a $5,000 fee, she told me, "Must be nice to make $5,000 for thirty minutes of work." See, no one sees the incredible amount of effort that goes into the back end of speaking. The countless hours spent producing new talks, marketing, negotiating contracts, customizing appearances, traveling to the event, dealing with follow-up, and so forth.

And it's that way with artists too. People notice the $2,000 price tag on a wall-size painting and say, "Must be nice to charge so much," but they have no idea how much work went into creating that piece. I was speaking to a wood carver who was charging that amount for a piece that took him two years to complete. If he spent an hour a day on that carving for those two years, and if his buyer pays what he is asking, he will have earned $2.73 an hour for the work he did. That's far less than minimum wage. Doesn't seem like such a high price anymore, does it?

We artists love our work. That's a perk. But that doesn't mean it's easy and that doesn't mean we don't need to be paid fairly. In the speaking profession, there's a lot of talk about "charging what you're worth." It's scary, but it's necessary. In order for us to do the work we were born to do, in order for us to use our talents to best serve our communities, we must be able to keep our doors open.

And there's one thing you can count on with artists and creatives of all kinds: we will rarely let our work get easy. Why? Because once it does, it's no longer a challenge and it's no longer unique or original, which is what we think you deserve.

○

SPONTANEITY VERSUS PLANNING

I was sitting in a focus group the other night, and the facilitator threw out an icebreaker question: "What do you miss most about being a kid?"

I said, "I miss spontaneity. You know, deciding you were in the mood for tag and then knocking on doors until you found some kid who could come out and play." In the grown-up world, if I want to see a movie with a friend, we have to schedule it three weeks out.

Maybe artists are more attracted to spontaneity than the average Joe because creative bursts so often hit us out of nowhere. Maybe we learn to equate spontaneous brilliance with satisfaction.

I wish I could wake up every day and say, "What do I *feel* like doing right now?" But the real world doesn't allow that. The real world demands that bills get paid and kids get fed and errands get run. Like it or not, to a certain extent, every artist needs to plan.

So, how do we strike that balance between planning and spontaneous exploration? We're not really the types to devise five-

year plans, and even if we did, chances are it would change entirely by year two. Or worse, we'd get so fixated on our plan we'd fail to recognize growth opportunities when they appeared.

On the other hand, it's bad business to just move forward willy-nilly. While the Law of Attraction does work, it's not really true you can manifest money without putting in some focus and effort.

It behooves us as artists to sometimes step back and evaluate where we are on our career path, revisit our goals, restructure our workdays, move beyond projects that aren't gelling. It takes some periodic soul searching to keep us on our path. And sometimes it takes admitting that we've reached a fork in the road and must decide if a whole new direction would serve us better.

We are artist-entrepreneurs, like it or not, and if we believe in our art, if we value it and want others to as well, we have to sometimes step back and ask ourselves what we need to move forward. Is it more money? A better work space? A more encouraging group of friends? If so, how do you plan to improve those areas of your work and life? How can you better support yourself so you can bring your best art to the world?

○

Bursts of Brilliance for a Creative Life

THE POWER OF COMMITMENT

There's a project I've been wanting to work on for months now. And though I keep putting it off, I also keep talking about how much I need to get it done.

"So, what would it take to make you do it?" my husband asked.

"A deadline," I answered.

But here's the funny thing about deadlines: When promises are made to other people, clients or colleagues or bosses, we tend to deliver on time. But it's harder to keep promises we make only to ourselves. It's difficult to follow through when no one is really holding us to it. That is one of the ongoing challenges for artist-entrepreneurs.

Here's what I did regarding that project: I contacted a friend and asked if we could set a schedule to meet to review my progress. And I picked a friend who will offer little sympathy for my excuses. That's important. I'm going to get it done just so I don't have to tell her I didn't.

If you're finding it hard to follow through on a project you care about, find an accountability partner or set up your project so that people are excited to see your progress, because that makes it feel like a commitment!

If you find you are still missing deadlines and still making ex-cuses, that's probably a sign the project isn't something you feel passionate about. If that's the case, it may be better just to let it go. No sense wasting energy beating yourself up over something that's not a good fit. Better to use that energy to push yourself toward something that really matters!

○

40 DECISIONS A DAY

A study found that mothers make 40 decisions a day. That's 280 per week. Well, heck, I could have told you that. But it got me thinking about artists. We easily make a like number of decisions in a single day. Some are big and some are small, but all seem important.

I'm quite sure I make 20 decisions a day just based on the e-mails in my inbox. Should I donate to another silent auction? Should I agree to a discount a buyer has requested? Should I say yes to a speaking gig that is far out of town? Should I renew my domain names for another year? Should I agree to that guest post on a blog I've never heard of?

Then there are the decisions we make on behalf of our businesses. What price should we put on our new product? Should we take out an ad? Should we agree to partner with another artist on a joint venture? Should we pay for a booth at an event?

And that's to say nothing of the decisions we make regarding the art itself. What color should we apply to the painting next? Which director should we choose for the new show? Should we add another verse to the song or leave it as is? Should we massage that troublesome story line or get rid of it?

Even the "simple" decisions are sometimes surprisingly hard. Naming a character in a book, for example, sounds easy but can take hours. If you give your characters the wrong names, they tend not to cooperate with you. I sometimes think there is no such thing as an easy decision when you're an artist.

If you're an artist-entrepreneur *and* a mom, you're likely making over 100 decisions a day! So, the next time you're beating yourself up for not getting enough done that day, cut yourself some slack. Even on a bad day, you've made 50 decisions! That's more than a full day's work.

No wonder we're all so exhausted.

○

HOW TO BE IN THE FLOW AND STILL KEEP LIVING

I've always prided myself on being one of those people who never drops the ball, no matter how many I'm juggling. People ask me how I stay so organized and on top of things. Oddly, I don't think of myself as organized (you should see my desk), but I do take my responsibilities seriously.

But lately, I've been doing some deep thinking and exploration that require a certain type of focus. Suddenly, this past week I got my times mixed up for two different appointments, and there were a couple of other small balls I dropped. It was a goal of mine this year to relearn how to do "deep focus," but I'm discovering the more deeply you're focused, the less notice you pay to the little things.

Maybe my concern over all of this goes back to one of the many myths we maintain about artists: that artists are flighty, head-in-the-clouds, overgrown children who don't notice when their shoes don't match, much less when they've forgotten to pay a tax bill. I've spent my entire career trying to debunk that and so many other myths about artists.

Then again, there is some truth to the distraction of being "in the zone." When the creative juices are flowing, it's hard to

stop and address other things, no matter how important. It's very possible, even probable, you'll lose that great work if you end it too early, but I don't think this is an issue specific to artists. I've seen it happen to scientists and nurses and even mechanical engineers—in other words, anyone who is working to solve a problem, come up with a solution, or just provide an extra layer of care.

How do we strike that balance between surrendering to the flow and maintaining responsibility in our lives and business? Well, Hemingway used to make a practice of stopping his writing mid-scene so when he came back to the page the next day, he knew right where to start. He believed the subconscious mind would continue to piece together the work while he went on with the rest of his life. I like this approach because it gives me permission to stop when I need to and still believe the work will not suffer.

○

ARE THE GATEKEEPERS STILL RELEVANT?

Several times over the past few years, I've had colleagues tell me that an editor who loved his or her work had called, sometimes in tears, to say they couldn't make an offer on my friend's book. Why? Because the marketing and sales department decided that the book, though good, was not "marketable enough."

We used to think of editors at publishing houses as gatekeepers. It was an honored, almost revered position. These were the people we trusted to not only recognize quality, but to nurture true talent, take pride in discovering something unique, and toss out the garbage. Today, though, the gatekeepers are not always the trusted guards; they're often the jesters, dancing to whatever tune pleases the court. And if the court wants crap, that's what they're forced to deliver, on a silver platter, no less.

The tide is turning now against the gatekeepers. Some argue it's the public who will decide what succeeds and what fails. But this is nothing new. It was *always* the public that decided. We made sleeper hits out of stories that had received modest launches and tanked books for which publishers had paid exorbitant advances. We, the "fickle" public, have always been a burr under the gatekeepers' saddles.

But the absence of the gatekeepers is making some people nervous. I read an interview recently with a traditionally published author in which he said, "Nowadays anyone can print a book and call themselves an author." But wasn't that technically true all along? It's not that the possibility never existed before, it's that we never chose to see it. Reality hasn't changed, only the way we define it has.

So, if anyone and everyone can be an artist these days, if the gatekeepers are no longer anointing the chosen few, then aren't we doomed to suffer a lot of bad art? Yep. We're also guaranteed to discover new forms and styles that would never have been "approved" under the old systems.

Now that the gates have been flung open, though, and any old peasant can publish a book, the gatekeepers are defecting the castle and heading out into the villages to peddle their skills to the unwashed masses. And I, for one, welcome them. Please bring us your knowledge, your experience, your acute editorial eye, and your passion for quality literature. And bring with you those awesome stories that your publishing houses passed on, so we can read and enjoy them. Work with us to do what an editor is supposed to do: help us write the best damn books we possibly can and bring them into the world.

Because in the end, it's not the gatekeepers who truly decide. It never was. It's the marketplace. The arts are no different than any other business. If you open a restaurant with all the best intentions but the food is bad, your restaurant will fail. No one

will come back, and no one will recommend it. The same is true if you open a clothing store and sell cheaply made goods or start a dog-walking service that operates only one day a week. It's still about quality and delivery and service and connection. It always was.

O

NEVER TELL ME THE ODDS

The other day, I heard a 28-year survivor of cancer share her story about the day she received her diagnosis. When the doctor gave her the bad news, she started to cry, of course. Then she asked, "What are my odds of survival?"

"It's just a number," the doctor said.

"Then don't tell me," she responded.

Only years later did she learn her odds had been 15 percent.

If you're pursuing a career in the arts, you know there are plenty of odds standing in the way of your success, and plenty of people happy to tell you all about them. People take pleasure in quoting to us the statistics about how few books actually make it to the bestseller list, or how few songs become hits, or how few plays make it to Broadway.

And even if you tell them your goals and ambitions are not so lofty, they're pleased to tell you how dismally low are the odds of anyone discovering your work at all, the implication being, why bother?

I could quote you all kinds of grim statistics about our industry. I could also remind you that the success stories you hear ·

are rare, which is why they make the news. I could tell you chances are you'll never make a profit off your art or even earn enough to afford your tools and materials. I could weigh you down with dire predictions, sad stories, and promises of failure, but I won't. There will be enough people on your journey who will do that for you.

When I was 13, I fell madly in love with Han Solo. His motto became my motto: "Never tell me the odds." You may also recall he always made that statement *after* C3PO had told him the odds. It's not like he didn't know, it's that he chose to power forward anyway.

In the end, the odds are just a number. Your success is determined only by the goals you set for yourself, not the expectations of others. So, power on.

○

PART IV

The Courage to Create

ARE YOU LIVING YOUR ART?

In late September 2016, my cousin Geoffrey Beard passed away at the age of 54. He'd been battling a disease his whole life and fought it right up to the end. This was a man who passionately wanted to live and to live his art. And he did just that.

Geoff was five years older than me, so as a kid I looked up to him. When he graduated college and became a graphic designer, I watched with fascination and respect as he honed his skills, grew in confidence, and built his business. He was my firsthand example of how a true artist should approach his or her work. He loved what he did, but he also respected his craft and understood the need to work well with his clients.

Like so many artists, he was called on often to donate his talents to nonprofits, creating materials and logos for many, and giving back in other ways.

Though Geoff desperately wanted to live longer, and I so wish he had, he pursued his passions and, despite the challenges, built the life he desired. I'll always admire him for that.

Are you living the life you want to live? If you found out tomorrow you had only a few weeks left, would you have any regrets? It sounds trite, I know, but every day is precious.

It's not good enough to keep plugging away at a boring or un-fulfilling job just to pay the bills.

It's not good enough to keep putting off your true goals until you retire, because there's no guarantee you'll have the ability to then pursue them.

It's not good enough to keep waiting until the timing is right or there's enough money in the bank or everyone else in your family is on board.

Life is a gift. Your art and your talents are gifts. Don't squander them. Time may be shorter than you realize.

○

NO GREAT STORY EVER STARTED WITH "I THINK I'LL TAKE A NAP"

A friend of mine recently attended an afternoon writing panel on which I was speaking about Strong Women in Children's Literature. She'd had a busy morning. She'd worked out and followed that with a heavy lunch with her family. She was tired and tempted to skip my panel in favor of a nap. After the event, she told me how glad she was she'd decided to forgo sleeping and come to the event, where she felt educated and inspired. "I reminded myself, no great story ever started with the character deciding to take a nap," she said.

What a good lesson that is for all of us. We're all so terribly busy and overwhelmed and just plain tired at times. And our art and the study of our art can feel like one more thing to add to our plates. Even those of us who do this full-time find it tempting to skip work some days in favor of a long walk in the sunshine or finishing the last two chapters of that awesome novel we've been reading.

But like most things in life, once you sit down and put some attention toward your art, you typically get drawn in. It might take a few minutes, but pretty quickly you get a sense of where

you left off and start to feel that tug to move forward. That's why it's so important to set regular hours to pursue your art. Even if you can't do it every day, knowing there's a time that week you have dedicated to your project will help you stay focused and on task. And while you're away from your desk or easel or musical instrument, your mind will know that deadline is approaching and will work subconsciously to get you ready for your date with your art.

Relationships take work. If you're going to court your muse, you need to give her some time and attention. She needs to know she matters.

So, no more excuses. You can sleep your way through life, or you can engage. What's it going to be?

○

YOU HAVE TO OWN YOUR ART

Is it really this simple? You announce to the world you are an artist, a dancer, a singer, and, voilá, you are. Yes and no. I was both terrified and exhilarated when I quit my low-paying job years ago to become a writer. I didn't tell many people at first. I had to figure out what to call myself. Back then, I was writing articles for newspapers and magazines, while also working on my fiction. So, I told people I was a freelance writer. It sounded more like a real job, and less like a lofty dream.

In time, my children were born and my writing workload decreased. Then I told everyone I was a stay-at-home mom who "did some writing on the side," as if it were a hobby, not my life's ambition. After a while, in addition to articles, I started getting some literary work published, and now, truly, I could call myself a writer. But I didn't. Not for a while.

Finally, I decided if I was ever going to see myself as a writer, I needed to own the title. A doctor doesn't say, "I dabble in medicine." A teacher doesn't say, "I spend part of my day helping kids." So, one day someone asked me what I did for a living. I took a deep breath and stuttered, "I'm a writer...but also a stay-at-home mom." Well, it was a step in the right direction.

If you want to succeed in the arts, you have to own your calling. You have to declare to the world this is who you are and this is your work, not a distraction. You need to seek out the company of fellow artists who call themselves artists and count yourself among them. Create a business card. Put up a website. Teach your friends and family to respect your "work" hours by not calling or texting during those times.

As artists, our paths are constantly changing direction. Every time you start a new project, or introduce a new product, or add a new title to your resume, push your doubts aside and announce your intentions to the universe. We are what we say we are, after all.

○

Bursts of Brilliance for a Creative Life

WHAT IS YOUR PASSION?

Passion is an overused word in our society. People will say, "I'm passionate about pizza," or "My passion is shopping." But the definition of passion is "a strong and barely controlled emotion." I seriously doubt pizza makes you feel like you're coming out of your skin.

What *do* you feel passionate about? Your partner, your children, your faith, maybe your job? Sure, but what else? What do you care about so much you'd stand in the freezing cold and face water cannons and police dogs in order to defend? Is it the environment, equal rights for women, fair treatment of animals, or proper education for all children?

What causes and organizations do you support with your time and money? What makes you so riled up you'll write a letter to the editor, or call a congressman, or join a march? What so motivates you that you will promote it via a bumper sticker on your car or by sharing it on your social media? What do you *care* about?

Because the best art comes from passion. It comes from a yearning for "the answers," a need to set things right, a longing to serve, a desire to challenge, an eagerness to inspire, an

impulse to celebrate, a need to remember. Sometimes it comes from our passion for the wider world, and sometimes it comes from a more personal place, but it always comes back to those things.

I heard an interesting interview in which speaker Neen James explained how to become a "thought leader." She said, "Ask yourself two questions: What have you spent your entire life trying to figure out? And what drives you crazy?" What she's really saying is, if you can identify your passions, you can lead us all in new ways of thinking, feeling, and acting.

Come on, my artist friends, now is the time to embrace your passions and make some real change in this world. If not you, who?

○

TRUST YOURSELF

I once had the chance to interview Terri Norvell on a radio show I was co-hosting. She's an expert on inner trust. She made a comment that really stuck with me. She said, "If you can't trust yourself, you can't fully trust other people." And oh, how we need other people if we want to succeed.

She went on to talk about how some people trust themselves, but no one else. Other people trust others, but not themselves. And some people trust themselves so much at work they accomplish great things but doubt themselves at home. Or vice versa.

I've always been one of those people with strong instincts. When I was young, it was easy to make decisions and take risks based on gut feelings. As I got older, I started to question my instincts, usually based on feedback from friends and family. It took me a long time to realize I should trust my own doubts, but not those of others. Those doubts did not belong to me.

It wasn't until I was in my mid-40s that I learned to trust not only my instincts but also my skills, knowledge, experience, and wisdom. It wasn't until then that I started to build inner

trust into my decision-making process, and that's when my business really took off.

Nearly everything I do now is based on listening to that voice that initially tells me, "Say no now," or "This might work, let's learn more."

Terri mentioned inner trust leads to confidence, and that's true. But for artists, it's trickier than that. We have to first trust our work is good enough to put out in the world, then trust that people will buy it, then trust they will praise or recommend it.

When that doesn't happen right away, many creatives give up. Our success is based on talent, or so it seems, and talent is either there or it isn't.

So, fine, you were only given a certain amount of talent, but do you trust you have the ability to improve your skills, increase your knowledge, learn from your mistakes, and find your unique place? If so, you will take your talent as far as it will go. And there will be more to learn and celebrate from that journey than there will be from giving up.

O

Bursts of Brilliance for a Creative Life

ARE YOU READY TO TAKE A LEAP OF FAITH?

After completing a studies abroad program in London while I was in college, I got an unexpected invitation to travel around Europe for two months with a classmate. I was dangerously low on funds, had no backpack, and was still a fairly unseasoned traveler, yet I jumped at the chance, much to my parents' consternation.

We stored our big suitcases at a friend's house, and I packed everything I'd need for eight weeks on the road into two small tote bags, which I slung over both shoulders in a crisscross manner. It was neither a comfortable nor an efficient way to travel, and I looked ridiculous, but it worked. It got me around. And those two months turned out to be life changing, partly because few things went as planned, and I had to learn to think on my feet. I wouldn't trade that experience for anything.

There are times when we need to be prepared—when we need to plan, and save, and project. And times when we just need to take a leap of faith. Are you holding back on a new project or business venture because you think you lack the proper tools? Are you worried because your coffers are low? Are you afraid

you might look silly? If so, take a deep breath and ask yourself this: "Does it *feel* right?" If the answer is yes, then do it. If the universe is telling you to jump, then jump.

Sometimes the only way to grow is to get out of your head and into your heart.

○

IT'S ALL ABOUT ME

That's what I tell my husband and my kids when I'm feeling excited about something. Does that sound selfish? Maybe arrogant? Well, it's true. When it comes to my art, it *is* all about me, because only I can bring my particular art and vision and message into the world. Only I can choose when and how to create. Only I can decide which pieces to finish and which to set aside.

To truly own this expression—it's all about me—you can't come at it from a place of ego. It's not about garnering praise or accolades. It's not about proving yourself worthy. It's not about striving for acceptance or a place at the "cool kids" table. If it's truly going to be about you, it has to come from a place of purpose and a desire to bring something of value into the world. It's about tapping into the creative energy that flows through all of us.

It has to come from a place of faith and trust that our art is bigger than we are. It's not about whether your book sells a million copies; it's about whether it changes one person's life, even if that person is you. It's not about whether you become the next star sensation; it's about whether you had the guts to

try out in the first place. Sometimes, it's not even about the art itself. It's about what we learn about ourselves as we create it. In the end, the person we become, the life we lead, is our greatest work of art.

We tell our children they're unique and special and there is no one else out there exactly like them. If it is true for the child, why is it not true for the adult? At what point do we stop believing we are special? At what point does that knowledge equate to arrogance or self-centeredness? It's just a fact. Only you can create your art. It comes from your talent, your skills, your drive, your passion, your experience, your unique outlook. And whether it turns out to be brilliant or mediocre, it's still all yours.

So, what is keeping you from your art? Is it time constraints, family obligations, financial worries, fear of failure, fear of success? Whatever it is, stand your ground. Tell your kids, your spouse, your mother, your friends, "I'm sorry, but today, it's all about me." Say those exact words. Out loud. Own it. Then show us what you've got.

O

HOW DOING THINGS WRONG
CAN FEEL SO RIGHT

I was invited to a party at one of those studios where everyone drinks wine and paints the same picture. I've never been a good painter, and that night my right arm was hurting from typing all day. I didn't want to irritate it further by holding up a paintbrush all night, so I decided I'd just watch. But where's the fun in that?

I had a second thought…I'd paint the picture with my left hand. It would be an experiment in patience to see if I could handle the extra effort it would take to finish the painting and an experiment in creativity to see if using my weaker hand would trigger some other part of my brain. Secretly, I was hoping to make a new discovery. Maybe my true genius with a paintbrush had been hidden because I'd been using the "wrong" hand all along.

In the end, my piece didn't wind up looking that much different from many of the others, aside from the fact that the paint on my canvas was much heavier, no doubt due to my inability to control the pressure I was applying. I think you'd call the style "early preschool." This experiment served to remind me

we should sometimes break out of our routines in order to challenge ourselves and to reconnect with the pure joy of creation. Using my left hand forced me to pay more attention to each stroke; it caused me to work slower and with a bit more patience, but it also made me laugh.

Today, shake up your routines, take a risk. Face your chair in the opposite direction, work in a new medium, write something in longhand instead of typing it out, try a new angle in your sales calls, or take the day off and go do something you've never done. Reconnect to your love of art and have some fun!

○

REDEFINING FAILURE

What if failure doesn't exist? No, I'm serious. What if it's just a word someone invented because he was feeling down about his work and the word stuck?

It's not hard to imagine a time when this word didn't exist. There was a time when none of the words we use today existed. But at some point, we strung a few letters together to create words so we could express a feeling or share an experience. And from there, we used those words to cement the "rules" of our cultures. But just because a group of humans decided something was the rule, doesn't mean that rule is an absolute.

What if failure isn't "real" then? Not like air or water. Think about it: we have thousands of ways to define its opposite— success. We say to people, what does success look like to *you*? Success is allowed to be fluid. You can't pin it down. Not so with failure. Failure is universal. If you set out to achieve a specific goal and you didn't, you failed. Plain and simple. Why the discrepancy? It doesn't make sense.

What if failure isn't failure? What if failure isn't even a setback? What if instead of saying to someone, "Well, that failed," we said, "Hey, that almost worked."

What if failure was a tool, not an outcome? What if it enabled us simply to see what did or didn't work so we could improve our effort?

What if it was a means to judge competence, and an F on a report card didn't mean you were lazy or dumb or rebellious, it simply told the teacher something wasn't working for you?

Once we accept failure is an opinion, not a fact, we no longer fear it, not really. We know better than to fear things that don't exist. Still, there's part of us that will always *want* to be afraid, even of things we know are not real. That's why we seek out haunted houses, to test our bravery, to challenge ourselves, to feel the high that comes with fear. But that's a choice, see? We are choosing to scare ourselves. If you want to be afraid of failure, you can be, but that doesn't make it real.

Here's the thing about language: it's living, and it's changing all the time. What if we took the word *failure* and made it a compliment? "Hey, dude, way to fail. Man, I would never have had the guts to try that." Wouldn't that just change everything? Failure would no longer be a negative, it would be a positive. We can do that, you know. We can change the word's meaning. We could even move it out of existence if we chose to. We have that power.

○

Bursts of Brilliance for a Creative Life

THE ANSWER IS ALWAYS NOW

Should I start that book I've been wanting to write now, or wait till after my sister's wedding? Should I take that watercolor class now or wait until I have a bit more money? Should I go to that play I've been dying to see tonight, or wait to see if I can find someone to go with me later?

We ask ourselves these questions all the time, but it's easy... the answer is always *now*.

If your art is calling to you, it's doing so for a reason. You're feeling a pull toward something for which your soul is yearning. But our souls are much quieter than our minds. Our minds are loudmouthed bullies. They're quick to remind us *they* are in charge and they know best. They can beat down our souls anytime they choose. They've been building those muscles our entire lives.

But before our minds took over, our souls were stronger. They were our best friends and most trusted advisors. When we were children, we followed the longings of our hearts, not the dictates of our minds. A toddler doesn't ask if now is the time to stop and blow the seeds off a dandelion, she just does it.

I know what you're thinking...not that old platitude again. Return to the heart of a child. Heard it. But life is more complicated than that.

It certainly is, but rarely as complicated as we make it. Our souls aren't afraid to venture out on our own; our minds are. Our souls don't worry about money; our minds do. Our souls don't ask if something else is more important; that's our minds talking.

You go for a jog even if you don't want to. You learn a new skill to push your thinking. You spend a lot of time building the muscles in your body and mind. Why not spend a little time building the muscles of your soul? You might be surprised how much good a strong soul can do for you. And you don't have to wait. Do it now!

○

YOU MAKE IT LOOK EASY

Beginner's luck is defined as "unexpected success for someone who has taken up a new pursuit," and we've all experienced it. For example, the first article I wrote after quitting my job to become a freelance writer was picked up immediately. The second article landed on the front page and was quickly acquired for reprint by a regional magazine. *Hey, this is easy,* I thought. And I was hooked.

The same thing happened again with my first short story. It was picked up, despite being poorly written. Granted, I had sent it to a little-known magazine probably desperate for submissions, but that didn't matter. I was convinced I must be a good short story writer. The next four stories I wrote, though, remain unpublished to this day, and for good reason. They were even worse than the first.

Beginner's luck even applies to the business side of art. Say you decide to sell your paintings in galleries. Maybe the first owner takes one eagerly. This is easy, you think. But the next several galleries turn you down. Are you truly a good painter, or was your sale just beginner's luck? You go to 10 more galleries to find out.

Here's what I think: I think this particular occurrence is the universe's way of coaxing us into trying something new. It provides us an opportunity to gain just enough confidence to believe we could really do this. It offers a taste of the high that comes with success in order to get us hooked. It puts the right people in our path to say exactly the right things to make us *believe*. And once we believe, we're captivated. This is suddenly all we want to do.

And that little taste of success lingers. It continues to tempt us no matter how many disappointments we encounter. We long to recreate our initial triumph. We ache to feel once again that we are worthy.

And that's all good, because that longing pulls us forward. Ideally it spurs us to learn more, to try harder, and to work with more care and diligence. And it tests our willingness to stick with something. If we never experience beginner's luck, we are more likely to quit too soon.

So, take a chance, and if you succeed wildly, don't just write it off as beginner's luck and move on. Consider that maybe that early fortune is leading you toward what you are meant to do.

O

GO BEYOND YOURSELF

I was listening to an *On Being* interview in which poet David Whyte was recalling a story of a dinner with his writer friend John O'Donohue. He mentioned he was thinking of giving his father money and said the amount, and John said, "Oh, David, go beyond yourself. Give twice that much." David Whyte's larger point was that we should always be more generous than we are first inclined to be, and he didn't just mean with money or time. He meant with our gifts, our art, our love, and the wisdom of our souls.

What would happen if we all went beyond ourselves every day? If instead of saying no because we were tired, we said yes? If instead of holding back out of fear, we leapt with *real faith*? If instead of holding our tongues to avoid conflict, we spoke our truths? What would happen if we tried something new with our art? If we agreed to something else just because it felt right, and not because it might lead to something bigger? What would happen if we set our work aside for a day and gave ourselves time to breathe?

When I was young, the concept of going beyond myself seemed thrilling, if a little frightening. I had a lifetime to un-

cover my purpose and a dizzying number of paths to take to find it. Now, in midlife, it's sometimes easier to opt for comfort, quiet, stability. I'm too old to keep starting over, I sometimes think. I should just coast until retirement. At the same time, I worry I no longer have 50 years before me to figure out my purpose. And part of me hopes somehow, without my knowing, I've already fulfilled it. That's a peaceful thought, isn't it?

It's time to go beyond myself again. But that doesn't mean just picking up more work or filling my day with tasks I can cross off a list. I think I truly understand now the path that leads beyond is not an external path (I tried that route); it's an internal one. Now is a perfect time for meditation, reflection, contemplation, and exploration. Now's the time to let go and fall freely.

Go beyond yourself. Let's see where it leads you.

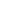

ARE YOU READY TO BE VULNERABLE?

The other day, I was meeting with one of my women's groups. We're all getting to know each other really well, and one woman asked a deep question. Another said, "Wow. You're asking us to be pretty vulnerable." And then we each answered, from the heart, and with faith we would face no judgment. It was an enchanting evening for me, to be among women who could share so deeply and with such trust.

The dictionary defines *vulnerable* as "susceptible to physical or emotional attack or harm." A vulnerable person, it says, is "in need of special care." In this overly judgmental, critical, opinionated, outspoken culture we live in, it's scarier than ever to show our true colors and speak our truths, and yet artists learn early on that our best work emerges when we turn ourselves inside out on the page or on the stage and let our audiences see what lies deep within us.

This doesn't mean we should air our dirty laundry or seek only to shock our audiences, but when we allow our emotions to show, expose our fears, acknowledge our regrets, and reveal what we've learned, we create what's called "universal appeal," which means our stories or songs or paintings are no longer

just about us. They become something our audiences can relate to, even if their lives seem nothing like ours.

I experienced this phenomenon again last night when I turned in an essay to my writers' group that exposed many things I'd kept secret my whole life or told only to my husband or very close friends. I trust the members of this group, and the time had come for me to write these things out of my being, but in doing so, I'd leave myself vulnerable to their judgment, misunderstanding, or ridicule. I knew in this group that wouldn't happen. But if they convinced me to publish the essay, I would be standing naked before strangers. I kind of hoped they'd say they hated it, and I could put it aside forever.

But they liked it. And they related to it. And they felt themselves a part of it. And that's the power of art. It takes our individual hopes and pains and says, "This is me. Is this you too?" And the answer is often a resounding yes. We are more alike than we are different.

So, be vulnerable. Tell us your stories. Share your shames. Admit your mistakes. Revel in your successes. Chances are we'll be too busy thanking you for giving voice to our similar joys and sorrows to judge you.

And for those who do judge, don't judge them back. That path leads only to pain. Just remember, their judgment is their weight to carry, not yours.

Here's what I'm learning: if being vulnerable requires trust, the first person I need to trust is myself. Trust I am strong enough to stand in my truth. Are you?

O

GREATER MUST OUR COURAGE BE

I've been a Shakespeare buff all my life. There weren't many big cultural events in Boise when I was growing up, but we did have the Idaho Shakespeare Festival, and my family went every summer.

A few years ago, I was contemplating a major change in my business and feeling hesitant—no, scared—about whether I should move forward. I accompanied my daughter to a photo session and, while I was waiting, noticed a volume of Shakespeare on the photographer's shelf.

"Okay, universe," I said. "Who better to advise a writer on direction than the greatest writer who ever lived? I'm going to open this book, and you're going to direct me toward a line that will tell me what to do." I took a deep breath, opened to a page, and pointed to this exact sentence: "The greater, therefore, must our courage be."

It doesn't get clearer than that. I moved forward on the plan for the business, and, though there have been many challenges, I'm glad I did.

My hero, Eleanor Roosevelt, once said, "Do one thing every day that scares you." I don't know how possible that is, but I know at least once a week I feel scared. And that's the way I want it. Because I've learned if I take those chances and brave my fears, I discover something every time. I learn I'm more capable than I thought, that failure is no big deal, that people can handle more than I think they can.

One year I decided to apply Eleanor's advice to my writing and pen three essays that scared me, mostly because I was afraid of offending my readers or getting pushback on my opinions. I wrote one of them and shared it with my writers' group, and that was terrifying. I have not yet written the other two. So, clearly, I am not yet fearless.

But that's okay. Many people in history have noted courage is not the absence of fear, it's the willingness to act in spite of it. It's scary to put our work out there in the world, scary to try to live up to expectations (our own and those of others), scary to quit our jobs to follow our passion, scary to think we may never achieve our goals, and scary to think we might.

And, like it or not, it's never gonna stop being scary. So, it's up to us to summon the courage and move forward. No one else can do it for us.

When was the last time a project frightened you? When was the last time you weren't sure you could pull something off? Have you gotten too comfortable, too complacent, too tired? If so, maybe it's time to take a risk. Maybe it's time for a little adventure.

PART V

What We Tell Ourselves Matters

WHAT DOES YOUR INNER CRITIC SOUND LIKE?

I used to think if I had an inner critic, it wasn't very strong. I don't hear voices in my head telling me I'm stupid or incompetent or ugly, so I thought I was safe. Turns out, our inner critics speak to us in different ways, and some are subtler. Mine often starts with the question, "Why can't you?" Why can't you figure this out? Why can't you learn this? Why can't you get more done?

As artists, we're in charge of every aspect of our work. We may get help from others at times, but the responsibility for the outcomes falls squarely on our shoulders. We are making difficult decisions all day long, and the consequences of our actions will directly affect everything we do. It's a lot of pressure. And our inner critics prey on that.

It's easy to tell someone to just ignore their inner critic. People say things like, "You just have to *believe* in yourself," or "Focus on the things you're doing right," or "Be kind to yourself, you're doing the best you can," to which our inner critics respond, "Yeah, right."

I've heard strategies suggesting we fight back against our inner critics or even befriend them. But what if I'm not feeling up to

a fight that day? What if I'm feeling too vulnerable to ignore? What if I'm feeling too angry to befriend? I believe there is never just one way to do anything, even conquer our demons. What we *can* do every time, though, is acknowledge them. Recognize them as part of who we are, but take away their power by refusing to let them define us. If we *all* have inner critics, then we're not in this alone. We're no better or worse than anyone else.

It's like I told my daughter before she headed off to college: "You're going to make a lot of mistakes. Don't you dare beat yourself up about it. Learn from your errors, correct them if you can, but remember everyone around you is making mistakes too. That's how we learn."

O

IT'S ONLY TRUE IF YOU BELIEVE IT

I was working with some of the kids at our local Boys & Girls Clubs one day as part of a program I was running, when I started to talk about college. One of the kids said, "My dad says I can't go to college because I'm not smart enough."

"Do you believe that?" I asked.

He looked at me quizzically then said, "No."

"Then it's not true."

A slow smile spread across his face. While it's always a bit dangerous to suggest to a child that his parent has told him an untruth, it can sometimes change the course of a life.

But it's not just children who buy into the beliefs that others hold about them. Adults do it too. And what's more, we buy into all kinds of other influences as well. We believe the results of "recent studies" and think they apply to us. We're affected by the labels applied to our gender, race, religion, and profession. We allow the media to tell us what is "real."

As artists we are especially vulnerable because everyone has an opinion on everything from the quality of our work to how we structure our businesses to how we live our lives. Because our

work makes us visible, we draw attention, and with attention comes judgment.

When was the last time someone told you you'd never be able to do something? Were they right? If so, were they right because you never really tried? In other words, just because they turned out to be correct, doesn't mean their statement was true. It's only true if you believe it.

Imagine all the people who told Orville and Wilbur Wright they'd never get their flying machine off the ground. If they'd quit, all of those people would have been right. But they didn't. They believed in their miraculous invention, and they changed the world.

Does that mean we can accomplish anything if we just believe? Let's say I'd wanted to change my eye color. I would have been told, rightly, you can't change your genetic makeup in that manner. Then along came colored contacts. Someone out there figured out a way to make a seemingly impossible wish become a reality. So, is there really *anything* we can't do?

Think of all the limiting beliefs that were heaped on you as a child. Some might even have been said in kindness, but good intentions also don't make things accurate. The only person who can decide what is true for you is…you!

O

WHOSE VOICE DO YOU NEED IN YOUR HEAD?

This book is called *Bursts of Brilliance* because that's what it feels like when you get a great idea, like the heavens opened up and handed you a gift. But that gift will pass you by if you don't seize it. And it will wither on the vine if you don't nurture it. I've seen far too many brilliant ideas fall apart because people, including me, listened to the wrong person at the wrong time.

If your idea is your baby, you must treat it like one. You must protect it from anyone who wishes it harm, even if that person is your best friend or your mother or your spouse. Be careful whom you first share your concept with. Choose someone who loves to ideate, someone who is good at brainstorming, someone who will share your excitement and put your feet in motion.

If you start to doubt that you are the one to build your idea, seek out that friend who is nothing but encouraging, the one who says things like, "You're kidding, right? You're a genius. You can do anything you set your mind to!" Fill up on her words of praise and move forward.

Now maybe you need the voice of someone who's good at strategy, someone who can fill the gaps in your knowledge or skills base. "Sounds great, but you need a plan. How about if you start here…"

When you're stuck and tempted to give up, call that friend who always offers just the right amount of push. The one who will reassure you that you have what it takes, you just need to apply yourself. "Quit your whining and figure it out. You know you can do this. This is your baby, no one else's."

At a certain point, when you're feeling strong enough, you'll *want* to seek out that "wet blanket" friend. "Go ahead," you might say. "Poke holes in this idea. I want to see what I'm missing."

If that person has beaten you up too badly, turn to the friend who makes any problem seem funny, because sometimes the only thing to do is laugh.

Lastly, you want to think about those mavens or favorite clients or colleagues who will champion your idea and be the first to get behind it, the first to buy it, the first to sing its praises and recommend it widely. They are the ones whose words of praise are going to echo in your ears, but also the ones who are going to move your idea forward.

It's important, especially to artists who often work alone, to think carefully about the type of feedback we need and when. Whenever I find myself feeling agitated, I say, "Whose voice do I need in my head right now?" And then I pick up the phone and call.

○

ARTIST, HEAL THYSELF

Remember that old proverb, "Physician, heal thyself?" I know its literal meaning is to make sure before you try to correct others that you are not guilty of the same faults. But I think most of us interpret it another way: we take it to mean that sometimes those of us who should know how to heal ourselves don't do it, out of either denial or impatience or egotism or an unwillingness to admit we're not sure how.

When I was writing my book, *Wave Me Good-bye*, I began to feel stuck. More stuck than I'd felt with any story in a long time. And none of the advice I would give to my past coaching clients or fellow writers seemed to apply to this project. Oh, I'm sure it did, but I just couldn't see it. Or maybe I was just being stubborn, like a doctor who knows what pills he should take, but still refuses to take them.

And the depth of my writer's block was also shocking and a little scary. I'd been a professional writer for 25 years, and I had six books and hundreds of publications under my belt. Shouldn't I know how to do this by now? If I was that stuck, did that mean I was not as good of a writer as I'd hoped I was? Not as good as I'd worked so hard to become?

Maybe that novel was a wake-up call, an opportunity to realize I still had much to learn. I picked up a writing book called *Story Genius*, which several of my friends had recommended. I also started paying more attention to articles on writing. I revisited how I wrote the first six books trying to rediscover my own methods. And I gave myself a pep talk. I told myself that maybe because the book was giving me so much trouble, it would wind up being the best one I'd ever written. But I also told myself it was okay if it wasn't. There would be plenty more stories, stories that, good or not, only I could tell.

Most importantly, I gave myself permission to be stuck. That book clearly had something to say that I wasn't hearing, so I needed to quiet my mind and listen. And you can't do that if your inner critic is shouting about how pathetic you are. It was time to trust I had it in me to heal myself and get past that block. I had the knowledge, the instincts, and the will. Artist, heal thyself.

O

IS YOUR ART TOO TRIVIAL TO MATTER?

When your art is flowing and you're in the zone, all's right with the world and you're everything you've ever wanted to be. That's not to say it isn't hard, but the challenge is somehow invigorating.

Recently, though, several of my artist friends have told me some of the luster has gone off their work. "How can I focus on my trivial dabblings when the world is falling apart?" they ask. "Isn't it selfish or naïve to think my art really matters when so many people are suffering?"

I feel that way too sometimes. But no matter how bad things have gotten in our world, most of the people we know are still showing up for their jobs every day. Doctors and teachers and journalists aren't asking whether their work is important, even in times of trouble. They know it is. But so do mail carriers, and garbage collectors, and restaurant workers. We're all needed, even when times get tough, and that goes for artists too.

Can you imagine if *every* artist dropped their "trivial" work to become full-time activists for the causes in which they believe? There would be no new songs or movies or plays or books to inspire and awaken us. And there would be no hope.

There's nothing trivial about what we do. My entire body of work so far has centered on preserving history so we can learn from it, honoring those who have been marginalized, speaking to the injustice of prejudice and the pain of bullying. My books have explored the themes of loyalty to country, the righteousness of war, the aftermath of suffering.

And they have celebrated the ordinary people working to make their nation and world better in whatever ways they can. My books are "just" fictional stories, and more than half of them are "merely" children's books, but their messages are as relevant today as they were in the 1940s, when my books are set. And they will be relevant 75 years from now too. What has your art been telling us? What do you hope it will say as we move forward?

Now is not the time to set aside your art—now is the time to recommit. I'm not at all saying artists, myself included, shouldn't advocate for the causes they believe in and use their talents and voices to further those efforts. Those actions matter! I'm just saying, don't minimize the importance of your art at the same time.

○

Bursts of Brilliance for a Creative Life

HOW TO BANISH ENVY

I was reading one of my friend's newsletters, and I said to myself again, "She is leading my writer dream life." If you're in the arts, you have at least one friend like this. Someone whose work you admire and whose talent you would never dispute. Someone whom you genuinely like…a lot. But he or she has something you've always longed for and striven for yet never achieved, and some part of you envies that.

You tell yourself envy is counterproductive, that you could sit around envying someone all day and it would accomplish nothing. You know you're better off focusing on doing your best work and reaping whatever rewards it brings your way. You remind yourself to feel grateful for what you have. You tell yourself it's not nice or Christian or enlightened to envy and you should rise above it. You convince yourself maybe that person just has better luck than you. Or you give them the benefit of the doubt and assume they've worked longer or harder than you. But no matter how much you try to outdistance your envious thoughts, sometimes they still catch up to you, and you look at your friend's latest accomplishment and sigh.

But you still buy every book this friend writes and see every play she acts in and show up at every concert she performs, because you know she is *that* good, and the artist in you can't stay away from great art. You hug her and tell her you're so proud of her, so happy for her success. And you *are*! And the next day you return to your desk or studio and hope and dream to one day achieve what she has.

But if you surrender to the work, those thoughts melt away. You feel the thrill of creation and settle into your natural rhythm, and you know that what you're doing is what you're meant to do. And she is doing what she's meant to do. And while her art may touch millions, your art may touch only a few, and none of that matters.

What matters is when you go to bed at night, you sleep knowing you have not turned your back on your own gifts out of petty envy and useless comparison. You have not short-changed yourself by pining to be something you're not. You have spent one more day in pursuit of art that only *you* can produce, and somewhere, someone is envying *your* courage to do just that.

○

SHAME, SHAME, GO AWAY

Brené Brown made it okay for us to talk about shame, both men and women. So, let's go there. Because it seems to me artists deal with more than our fair share of shame. And it comes at us from opposing angles, to the point where sometimes we feel we can't win:

"You spent all afternoon painting? Wish I had that much time to myself."

"Why haven't you been working on your writing? You were given a gift. You don't want to waste it."

"Aren't you ashamed charging so much for your work? Art should be affordable for all."

"Don't you feel bad not contributing more money to the family income?"

"Is it hard to be on stage every night, knowing you can't tuck your kids in bed?"

"You shouldn't ask your children to pose for your photographs. Kids should be allowed to just be kids."

"You play it pretty safe with your art. I think the best artists strive to be a bit provocative."

"I feel like you're trying to offend with your songs. What makes you think you're better than the rest of us?"

"You should quit hiding in your studio and get your art out there more. People need to see this."

"You submitted your work *there*? Wow, you must be feeling pretty confident."

"That piece you created is very personal, isn't it? I was always taught not to air my dirty laundry."

"I liked your piece, but I felt you were skimming the surface. A true artist needs to bare his/her soul."

Buried inside each of those comments are the speaker's own insecurities, hang-ups, disillusionments, judgments, and fears. On a certain level, we know that. We know their comments say more about them than they do about us, but somehow, we still feel the shame. It's easy; all our lives, we've been made to feel ashamed of our looks, our work, our parenting, our beliefs, our behaviors, our indiscretions, everything. We've been shamed by our parents, grandparents, coaches, teachers, friends, spouses, bosses, colleagues, pastors, children. All the people who matter most in our lives. No matter how good we feel about our art and the pursuit of our art, there's always someone happy to tell us we're being selfish, self-centered, arrogant, privileged, deluded, frivolous, or just plain foolish.

One of my favorite quotes from my hero, Eleanor Roosevelt (a woman who encountered shame in every aspect of her life), is this: "No one can make you feel inferior without your

consent." And this quote works if you insert the word *shame* instead. "No one can make you feel ashamed without your consent."

The whole point of art, after all, is to produce something that is all your own. Something that comes from your heart, soul, and mind. So, sure, I guess it's the ultimate selfish act. And that's good. Because how else will the rest of us ever learn from or be inspired by what is uniquely you?

As long as creating art brings you joy, fulfillment, excitement, challenge, and energy, it doesn't matter what anyone else thinks. *It's not your job to convince anyone about anything.* It's your job to be true to yourself. Period.

O

I'M DONE WITH THAT

As human beings, we reserve the right to complain once in a while. And lament and regret and maybe even whine. As artists who are somewhat solitary in the work we do, it's especially important to know where we can find a sympathetic friend.

When I'm listening to people talk about their troubles, my ears perk up when I hear two important words: *I'm done.* These words have so much strength and power it's impossible to even say them without a rise or fall in your voice or an increase or decrease in energy. Try it. I'm right, huh? When I hear those words, I know it's time for that person to either make a change or make a break from whatever is troubling them. After all, when something is done, you don't put it back in the oven hoping it will somehow get better.

Let's say your landlord keeps adding new rules to how you can use your studio space, or your band members aren't showing up for rehearsals, or your writing partner is shooting down every idea you have. If the words, "That's it, I'm done," cross your mind, you know you've reached your limit. You have two choices then: you can set up a time to have a meaningful conversation with that person and push for change, or you can walk away.

That's not to say you should necessarily drop things in a rush. Don't let your emotions get ahead of you. Think through what type of change you'd like to achieve and how you plan to work toward it. Whenever possible, you want to leave a troublesome situation without burning bridges or opening new wounds.

If fear is keeping you from addressing the problem, remember this: we do our best work when we can lean into our passion. If a situation is draining you of positive energy, if a person is bringing you down, if fear is holding you back, you will never achieve your full potential. It's okay to say, "I'm done." It's okay to move on.

○

WHEN GOOD WORDS TURN BAD

While listening to a friend talk about a moment of personal discovery, I had a realization: there are many words I use I'd always thought of as "good" words, but in certain circumstances, even a good word can turn "bad."

Take "wish" for example—a word full of positive energy and hopefulness. "Make a wish, honey," we say. But just as often when I say the words "I wish," they are followed by negatives. "I wish she'd stop that. I wish I didn't have to do this. I wish this wasn't so stupid."

And what about this one: "I am"? Such a powerful statement on its own, but just as often it might lead off sentences like, "I am not very good at that. I'm too slow. I am such an idiot."

Then there are words like "never" or "always," which for all the times they can be used in the positive, can just as often be used in the negative.

As a writer, two of my favorite words when paired together are "What if?" That question has spawned many a great story. But I sometimes catch myself slipping toward doubt when I use those words: "What if it doesn't work? What if she doesn't like it? What if I'm wrong?"

Then again, I'm just as likely to use a negative phrase in a positive way. Take the phrase, "So, what?" Makes you bristle just to hear it, right? But it can also be motivating.

"I don't want to submit this story. It might get rejected."

"So, what? Are you any worse off if it does?"

"I don't want to call her, she might say no."

"So, what? Then at least you'll know."

Language has power and there's no such thing as a good word or a bad word, there's only how we use them and how we pair them. So, be careful how you talk to or about others, but be careful how you talk to yourself as well.

WHY NOT?

A friend told a story of a mentor who once asked her, "Why not?" when she doubted she could do something. Two simple words, yet they spurred her to action because she couldn't think of a good reason why not. Typically, we launch into a laundry list of excuses. All the reasons why not. And sometimes we can hear as we're saying them how lame they really are. And sometimes they feel very real and very big and we can't imagine (yet) how we'd ever get past them.

And sometimes the words "Why not?" are so annoying. "Oh, don't make it sound so easy," we want to say. And sometimes, at the best of times, our minds turn that question over and over, and the more they turn it, the more everything starts to seem possible, as it did for my friend. And we say, "Yeah, why not?!"

I'd like to tell you that I respond most often with the latter reaction. I wish that were true. There have been plenty of times in my career when I've happily declared "Why not?" and thrown myself into something new, but probably more times when I've clung to my excuses.

Change is hard. Risk is hard. New steps in new directions are hard. And sometimes we just don't have the energy to say "Why not?" even when we want to. And, oh, how we want to.

So, what then? Do we make ourselves do it, energy or not? Passion or not? Do we trust people see something in us we don't see in ourselves? Do we trust that a mentor, especially, knows something we don't know? Do we leap, when we really just want to sit at the edge a little longer?

I used to think the answer to those questions was always yes. Buck up. Do the work. Take the risk. Find the energy. That's right, *find it*. It's your job. As a student of history, I've always been motivated by Teddy Roosevelt's quote, "Whenever you are asked if you can do a job, tell 'em, 'Certainly I can!' Then get busy and find out how to do it."

I'm not feeling that way now. I'm feeling more generous to myself. Maybe the reasons why not are not always excuses. Maybe they're not always laziness or fear. Maybe sometimes it's just not the right time. It doesn't mean you'll never do it. But if the energy isn't true, if it isn't authentic, if you're manufacturing it to prove something to someone else or to live up to their expectations, you're probably not going to put your all into it anyway.

So, trust your gut. When someone says, "Why not?" don't answer immediately. Think about it for a minute, feel into it. Ask yourself honestly if you're holding back out of fear or laziness, and if the answer is no, then tell them your reasons. Not your excuses, your reasons. It's okay to say no sometimes. It's okay to not take every path in the road. If we are to preserve the energy we have for the things that matter most,

we can't go down every side road someone shows us, no matter how tempting it looks.

When it feels right, though, when that person's confidence seems well placed, let those words be your battle cry as you run forward. Know that person has got you covered. Know he or she believes in you. Don't hold back. Give it your all.

Will you succeed? Sure. Why not?

O

WHO SAYS YOU ARE BEING SILLY?

I was watching a YouTube video of Lynda Barry, painter, writer, cartoonist, playwright, editor, and more. She told a story about watching a mother in a restaurant who was busy on her cell phone, while her four-year-old son tried to get her attention. When he couldn't, he started playing with his food, making up an elaborate story with his bacon. It was precious. Finally, the mother put down her phone and demanded, "What are you doing?" Poof, the moment was gone. The boy had been chastised for the unforgiveable sin of using his imagination.

This story stayed with me for days. Why do we do that? Why do we make kids feel bad for being "silly"? Why do we laugh at them when they try to sing a song or act out a scene? Why do we tell them they're not good enough to move forward with their art? Why do we insist they are "too old" to play?

And why do we, as adult artists, do that to ourselves? At least once a week, I ask myself, "What are you *doing*?" as if this work is somehow not worthy. I have to give myself permission to write, as if writing were something decadent or illicit or immature or "silly." I have to tell myself it's okay if I write a bad sentence. That doesn't make me a bad writer. I have to turn off

what Lynda Barry calls the "front of the brain" in order to hear the mystical whisperings going on in the "back of the brain."

Making art looks easy. It looks like child's play when we stand up there and sing or get messy with paint or jump up and down on a bed on a stage while playing a role, but it's actually hard work.

Who the hell decided that the creative inner workings of our minds, our imaginations, were somehow less valuable than the parts of our brains that calculate distance or add numbers or keep track of whether we took our vitamins this morning?

Our imaginations and the stories they tell teach us how to live, how to stay safe, how to get along with others, how to conquer our fears, and how to build new inventions to advance the human race. When a little boy is pretending to be a monster about to eat a helpless piece of bacon, he's exploring relationships and cause and effect and the distinction between compassion and cruelty. Artists do the same thing. They explore what could be, what should be, or what once was.

This is not play, but even if it looks that way, what's wrong with that?

○

BEING THE BEST

I experienced a minor disappointment when I failed to place in a contest I had entered. It wasn't a big deal, but for some reason, it got me down. In trying to figure out why I felt so bad, I had a realization. I told my husband, "When I was a kid, I always wanted to be the best in my class at *something*."

I spent a lot of time as a child wondering what it must be like to be the athlete who was always the fastest kid on the playground, or the girl who always got the solos in choir, or the kid who always scored the highest on the math tests.

What did it feel like to be "blessed"? What would it feel like to know you had a gift? Not a small gift, but the biggest box under the tree.

When my little hopes were dashed the other day, I felt like a kid again. If I couldn't be the best at writing, there wasn't much chance I could be the best at anything else. Writing was the closest I came in school to being the star pupil.

It always seemed unfair to me that some people are born with the voices of angels and others are born to croak like frogs. And then there are those of us who dwell somewhere in between.

Then again, with special gifts come more responsibility, more pressure, more expectations. Those of us who are average (or above average) can relax and just enjoy our mid-level talents.

It's kind of silly to sit around wishing we were the best, because who's to say we aren't? To our biggest fans, to our families and friends, maybe we are the best. Or maybe our talents are so outside the norm it's unfair to judge them in standard ways. Or maybe we are so busy obsessing about being the best at one thing that we don't realize we *are* the best at something else. Or maybe we're the best some days but not others, and that's okay. It's all okay.

Because it's not about being the best, it's about *feeling* our best. It's about leaning into those moments of awe we sometimes have at our own efforts, when we put our hearts and souls into what we're doing and it all seems to come together. Maybe those around us can't see it, maybe they can, but the point is we *feel* it. We *know* it's good. We know it's our best. And nothing beats that feeling.

Wanting to be the best is ego, wanting to do our best is soul. Ego just gets me down. Think I'll stick with soul.

O

Bursts of Brilliance for a Creative Life

WHAT SHOULD YOU TELL YOUR YOUNGER SELF?

This week I attended a networking event in which a local business owner was given an award. The host of the evening, Nancy, conducted a short interview with the winner, whose name was Trish. One of the questions Nancy asked was, "What would you go back and tell your younger self?" Trish gave a long pause. And during that space, I'm sure every one of us was wondering what we would tell *our* younger selves. Finally, Trish said, "Nothing. It's a process."

That was *not* the response we expected. Nancy asked us all to stop and let Trish's answer sink in, and I was grateful for the opportunity to do just that.

See, if you'd asked most of us that question, we would have felt obligated to advise our younger selves. We spend far too much time in the past wondering what could have been, what should have been, what might have been. We often revisit our "mistakes" and wish we could do things over. We're constantly apologizing to ourselves or others for failing to take that chance or for doing something because we thought we should. We spend a lot of time wondering what on earth made us think something we did was a good idea. Why didn't

we *know* better? And all that ruminating brings up feelings of guilt, shame, embarrassment, sorrow, resentment, and self-loathing.

But what if we didn't go back in time? What if we just accepted that who we are now is a result of our failings as much as our strengths? What if we let go of all the old heartaches and expectations and just focused on where we are now? What if we also let go of past successes that cannot or should not be repeated? What if you didn't offer advice, but only asked yourself, "What feels good about my life today and what can I let go of because it no longer serves me?" As creative beings we have the power to imagine anything. How about we imagine that our younger selves are just fine the way they are? They may be hurting or scared or misled, but they're also strong and wise and free. They'll be just fine. And so will we.

O

HOW SELF-IMPROVEMENT CAN HELP
YOUR ART AND BUSINESS

I made a commitment at the end of last year to devote my-self to self-betterment this year. By that I meant learning to meditate; creating more space in my life for contemplation and introspection; finding more time to read and attend classes; re-leasing old grudges, negative thought patterns, and pressures I put on myself; and tapping more fully into intuition and the divine. So, what have I discovered in the five months since I started this process? That self-improvement is a full-time job!

I've learned so much since the year began and found myself very often inspired, motivated, and much more at peace. I'm really liking my new self and my new life. But in this dedica-tion to living "in the moment" and to creating space for quiet time, I've found I'm not as productive in my work life as I once was.

I'm taking longer to respond to e-mails, falling behind on sim-ple tasks, and feeling less inclined to launch new projects. But with my new focus on silencing my inner critic, I find I can't beat myself up over that anymore. That's a good thing, I know, but don't forget, I'm my own boss. If I don't kick my butt now

and then regarding my work, who will? Guilt and shame were great motivators for me for a long time.

But here is what I'm coming to believe: all this quiet time, all this contemplation is leading me much further into preparing for my future in better ways than the old five-year plan and spreadsheets filled with tasks. It's causing me to finally get clear on what matters to me in my work, what I do best, what gives me energy, and how I can best serve. And with the absence of judgment, I'm finally, for the first time in years, starting to see where I actually want to go and how I can best use my gifts.

That doesn't mean I can just ignore my work life and sit in the sun all day. There are still bills to pay, commitments to fulfill, and good work to do. I have no intention of dropping any important balls, but I'm realizing this work I'm doing on self is now also an important ingredient that deserves to be tossed into the mix and honored as well. And when you get clear on what you want, things really do start to align. Turns out the old masters were right; the answers really do lie within us.

O

IT IS SAFE TO STAND IN MY POWER

A few months ago, I was chatting with my friend, Jean Marie DiGiovanna, who is a brilliant and successful speaker, but also happens to create unique jewelry on the side. I asked if she had any new pieces, and she directed me to a website page. I went the next day and found a bracelet that took my breath away. It was brass and stamped with the expression, "It is safe to stand in your power." That was a message I needed right then. So, I bought it.

Months later, I decided to call Jean and ask her about the bracelet. Why did she choose that saying? "You know," she said, "I tend to create work that I personally need, and then I just trust that maybe someone else needs it too. I was heading into a new direction with my work and feeling a lack of confidence, and that phrase just came to me. 'It is safe to stand in my power.' So, I created the bracelet for myself and then decided to sell a few too."

And I'm so glad she did. It's been on my wrist since the day it arrived. Wearing the same bracelet over and over is not something I typically do. But it is serving as a constant reminder for me right now to trust in my own power.

Jean's comments about creativity are important too. While it's true that sometimes artists have to do projects we don't want to do, it's also true most of our best work comes from a place of passion, excitement, joy, and release. Our greatest work usually stems from a bit of self-exploration. But this can feel self-indulgent at times. Who else gets to spend their day doing exactly what makes their heart soar? Well...hopefully everyone. I hope accountants *love* running those numbers and truckers *love* driving those long hauls and mail carriers *enjoy* stuffing those boxes. And if they don't, I hope they find something else to do.

We need to trust, as Jean did, that when we follow our passion and look deep inside, we will create art that is authentic and inspiring. It may not resonate with everyone, but it doesn't have to. It only has to speak to the people who need it most. And there will always be so many more of those people than you will ever know. Trust that too!

○

Art Is the Great Connector

HOW TO SING, PAINT, WRITE, AND ACT
YOUR WAY TO A FULFILLING LIFE

At the famous Wildflower Festival in Crested Butte, Colorado, the scenery and flowers were stunning. I took some pretty good pictures, I thought. Then a couple of days later, a friend posted on Facebook some flower pictures she took in her backyard garden, and they blew my shots away. Clearly, I still have a lot to learn about photography.

Likewise, there are moments, when I'm singing in the shower or the car, when I think I sound pretty damn good. Then I get the chance to hear one of my singer friends perform and realize, I still have a lot to learn about singing!

A while back, I attended an event in which the cartoonist from *The Economist* spoke, and he also taught us how to draw a caricature of President Obama. I've never thought I could draw anything other than stick figures, but my Obama was not that terrible. Apparently, I could learn a lot more about art, if I wanted to.

Last week, to celebrate my birthday, I wanted to do something outside the box and a little outside my comfort zone, so I took a class called Accents for Actors. I'm glad I went. I learned a

lot, but I was in way over my head. I definitely have a lot to learn about acting.

That is what makes the arts so much fun, whether you pursue them professionally or as a hobby. These are things that, on a certain level, look like they should be easy, but they're not. On the other hand, almost anyone *can* learn to play the piano or paint with watercolors or write a short story. And the more we learn, the more whole worlds open up to us; the more conversations we can have with strangers when we discover shared hobbies or passions; the more we start to pay attention to the art that surrounds us when we travel or visit a new friend's home. Even if we only dabble in certain art forms, the efforts bring us pleasure and stretch us inside and out.

So, this weekend, whether you're playing the only song you know on the ukulele and singing around the campfire or going to a songwriter's workshop to get better at your craft, tap into how art makes you *feel*, and the joy it brings to others, and be grateful art is a part of your life!

CAN A SINGLE ENCOUNTER WITH
ART CHANGE A LIFE?

When I was 12, my mother took my brother and me to see a performance of *Jesus Christ Superstar.* She'd taken us to children's theater productions before, but this was my first time seeing a truly "grown-up" play, and I was utterly transformed. I was a churchgoing kid, but never had I pictured Jesus or Judas or Mary Magdalene as truly human before.

The show also changed my view of the role of music and lyrics. Prior to that, songs were just something my friends and I listened to for fun. This was the first time I understood the power of song to convey something deeper. Within weeks, I had the soundtrack memorized.

That performance—staged in a high school auditorium using local actors in down-to-earth Boise, Idaho—made me a lifelong theater buff. Now, hardly a month goes by when I'm not paying money to sit in a theater. I've saved every program from every play I've ever seen, but I lost count at 500. My children grew up going to the theater, and now two of them enjoy acting, *their* lives transformed because I happened to see one musical all those years ago.

These days, I take kids from the Boys & Girls Clubs to see performances at our local children's theater. Nothing beats the sound of a small child gasping in wonder as actors make magic on a stage. There is one boy who has come to all four of the shows I've sponsored. Will he be a lifelong theater lover? Will the others? I hope so.

That's why it's so important to put artists in front of our children—in their schools, at their churches, through their Scouting troops, through free programs at libraries and colleges. That's why we need to point out to our kids the murals on the sides of buildings and stop to watch the street performers and take them to the bookstore so they can choose a book of their very own. Because you never know which encounter with art will change your child forever.

○

Bursts of Brilliance for a Creative Life

A LITTLE APPLAUSE FOR THE AUDIENCE

I recently saw a touring production of the Broadway show *Something Rotten*. It's a hilarious story about two brother playwrights who are trying to compete with their rival, the great and popular William Shakespeare. Though written for anyone, the show has special appeal to musical theater and Shakespeare buffs. It's full of references only we would get.

We were there on a Thursday night, and the Buell Theater in Denver was full but not sold out. Still, it was one of the most enthusiastic audiences I'd seen in a long time. After the numbers "A Musical" and "Hard to Be the Bard," the applause went on so long that, at one point, the lead actor actually laughed in disbelief.

You see, we weren't just applauding well-performed numbers, we were applauding ourselves. We were patting ourselves on the back for getting all the subtle and not-so-subtle references to the things we love—musicals and Shakespeare. We were sharing those passions with everyone else in the theater who got them too, audience and actors alike.

When art really works, it doesn't just ask us to notice or observe, it asks us to participate. We don't just "read" a book or

"listen" to a song or "watch" a play, we *experience* them. We become part of them. We see ourselves in the characters, we recognize our own feelings in the lyrics, and we imagine ourselves into the worlds we are visiting.

This year, I read the book *A Man Called Ove*. On first appearance, Ove is nothing like me. He's an older man, a curmudgeon, a Swede, and yet, the entire time I was reading that book, I was thinking, "Oh my God, this is me. I'm Ove."

So, in the end, our art is not about us, it's about the people we hope to reach. The ones who will read our books or watch our plays or listen to our songs. It's about being raw and showing ourselves so they can see themselves too. Sometimes they'll laugh, sometimes they'll cry, and sometimes they'll hate you for what you show them, but always, a connection will be made.

○

YOU CAN SAY IT ALL IN A GLANCE

One of the things I love about being married is exchanging those "knowing glances" with my husband. They occur when, say, one of our kids has just declared with great conviction he or she is going to do something we doubt they will actually follow through on. All we have to do is look at each other to know we are both thinking exactly the same thing.

To be fair, there are times I exchange knowing glances with my kids when their father is, say, missing the point. We do it with our coworkers when our bosses are being unreasonable and with our friends when someone says something unintentionally funny and with our siblings when our parents are driving us nuts.

We art lovers do this too. Have you ever sat in the back of a room listening to a singer who hits a note so perfect you glance at a total stranger and smile, and he or she smiles back? You both heard it at exactly the same time, and you both reveled in it. There may be people in the room who didn't recognize it, and that's okay. It only takes one other person to create a bond.

In those really special moments, when the art is especially powerful, we turn one way and then the other seeking out

those sympathetic eyes and finding them all around us, and the energy in the room begins to swell. Those are the events you remember all your life.

It works the other way too. You might be sitting in your writers' critique group and point out a plot twist so unlikely it'll never work. While the author is insisting it will, the other members are glancing at you and each other knowing full well it won't and wondering who will be the one to say so. Those knowing glances give us confidence and courage to say what needs to be said.

We humans are adept at so many forms of communication. We forget that sometimes. We rely too often on our words. But it's often through those knowing glances we find the people with whom we are meant to connect.

If you're not experiencing this phenomenon, maybe it's time to ask yourself if you've found your true tribe. If not, you may need to seek out a new circle of friends. It'll only take a glance to recognize them.

○

SING IT AGAIN, MOM

I love to sing. That's not to say I'm great at it. I can carry a tune, and I'm game enough to massacre a song or two at karaoke, but my favorite way to use song has always been to get my kids' attention. As they were growing up, whenever they were ignoring my directives or I just wanted to get a laugh, I would sing some popular song but change the lyrics in a humorous way. I might take an *Aladdin* song and turn it into a plea to clean their rooms. Or a Queen song might morph into a request to stop arguing.

Whenever I'd start singing, they'd stop what they were doing and stare up at me with expectant faces, waiting to see if I'd nail the rhyme or blow it. Eager to see if I'd crack them up or just crack myself up.

The other day we were riding in the car, and I was singing along to a popular song on the radio called "All of Me" by John Legend. I mucked with the lyrics, and the joke worked: *All of me, loves some of you. Not the part that's kind of lazy. Not the part that drives me crazy.*

"Mom, stop!" my grown son pleaded, laughing. But I'll never stop, and he knows it.

How does your family "play" with art and personal expression? Did your dad dance you around the living room when his favorite song came on? Did your mom hide silly doodles in your lunchbox? Could your grandpa recite the entire poem, "Charge of the Light Brigade"? How many of the inside jokes in your family relate to your relatives' having fun with art?

I've long been interested in all the different ways art affects us. Today, it's just fun to think some of those ways might be forming cherished family memories and weaving us all a little closer together. Aren't we lucky?

O

WHY BAD ART MATTERS

Most of the music enthusiasts I know would admit that "Achy Breaky Heart" is one of the dumbest songs ever recorded. Why is it, then, whenever someone mentions that song, it gets stuck in my head for days?!

And all of my writer friends agree that *Bridges of Madison County* is one of the most poorly written books ever published, yet it has sold over 50 million copies.

How is it that sometimes "bad" can feel so good?

The truly pompous critics would argue the general public lacks the sophistication to recognize bad art, but I don't think that's true. I've heard book fans say, "I know the writing is awful, but I still love that story." Others would argue there must be some "universal truth" within the bad art that strikes a chord. Maybe. But that seems a bit lofty at times.

I think part of the appeal of bad art is it allows us to feel superior. While most of us lack the skills or confidence to comment specifically on what makes a masterpiece a masterpiece, nearly all of us can recognize a corny line in a movie or a crack in a piece of pottery.

And with a sense of superiority comes courage. Art no longer seems so intimidating. How many times have you heard someone refer to a bad piece of art and say, "Well, *I* could do *that*."

Mostly I think our love of bad art comes down to this: no one wants to feel alone. When we take to the dance floor to mimic the moves of some silly new dance craze, we point at each other and laugh. We *know* we look ridiculous, but it's okay, because everyone else looks ridiculous too.

We can gather in our book clubs and collectively roll our eyes, we can sit in a crowded movie theater and groan in unison, we can nudge a total stranger and say, "Can you believe this crap?" And he or she will nod back.

In other words, bad art—just like good art—brings us closer together.

○

WHO WILL TELL THE STORIES?

When I was in college, I befriended a girl whose family members were refugees from Laos. She went by the name of Jenny because her teachers had deemed her real name too hard to pronounce. I learned it, though, and called her by that. I can still remember how to say it, though I can't recall how to spell it. So, she'll remain Jenny here.

Jenny invited me to her home one day, a small duplex in a modest part of town. She shared a tiny bedroom with her two sisters, her parents and youngest brother occupied the other bedroom, and her teenage brother slept on the couch. Her parents didn't speak much English, but they were welcoming to me. Her father was a janitor, I believe, and her mother took in sewing. Later, I learned their whole story.

Jenny's family had escaped Laos in the dead of night by hiding in the bottom of a fishing boat. They left everything behind, save for a few pictures her mother managed to sneak out, but what shocked my naïve 18-year-old self was that in their home country, Jenny's father had been a physician and her mother had been a teacher. They were educated, professional people who had once lived a more prosperous life. In America, they were just a few more "boat people."

I think of Jenny every time I see news stories about the thousands of political and economic refugees streaming across the globe these days, and I wonder how many of them are doctors or teachers or engineers. How many were shop owners or tradesmen or students in their home countries? How many were writers or artists?

I watch the news reports and learn about their journeys and about the implications of their arrival for the countries they enter, but I want to hear more of the stories. Because "refugee" was just a word to me until I met Jenny.

So, I'm praying the artists among those masses of exiles will tell those stories, and soon. Because no one expects to be a refugee one day. It just happens. But artists can help us understand how it feels when it does. Artists can change the meaning of a word.

○

IS THIS REAL?

Have you ever been watching TV or reading a novel and found yourself talking to the characters? "Stop!" you shout. "You're making a big mistake." Your spouse or roommate laughs and says, "Relax. It's not real."

Is that true, though? Because your heart raced. You felt it. And your mind formed the words to speak, assuming they could help. And for just a moment, you believed.

The greatest compliments I receive as a writer are when people ask me what happened to one of my characters after the book ended. "I've been worrying about Maggie and Colin for a week," one woman told me after reading *Remember Wake*. "Did their lives turn out okay?" I told her I wanted to think so, but I couldn't be sure. After all, they weren't "real."

On the flip side, a few months ago I attended a photography exhibit by Richard Renaldi called "Touching Strangers." The photographer had approached strangers on the street and asked them to pose together. The poses had an interesting intimacy. If I were a cynic, I might have responded to those pictures in this way: "Ah, those people are faking it. They're just acting that way because of the camera." And there might

be some truth in that statement. Some of those people maybe were behaving better or acting up more because a camera was present.

In other words, sometimes art works the opposite way. Sometimes it takes real people and makes us behave in a fictitious manner. Sometimes *we* determine the direction of the story.

And that's what I love about art. It blurs the lines. It creates alternate realities. It makes us believe the impossible and question the facts. Looking at a picture of a tranquil setting brings our stress levels down. Watching a horror movie revs our nervous system up. Reading a challenging book makes us question our long-held opinions or value systems. Hearing a poem about love lingering after death stirs our souls. These reactions are true. Art is as real as you make it.

And now, more than ever, we need our artists to help create our new reality by challenging our outdated beliefs, by stirring our emotions, by bringing us together and even driving us apart. Now, we need *your* art and stories. It's time.

Bursts of Brilliance for a Creative Life

A MEETING OF MINDS

"Everybody's stupid but me," the song says. And lately it seems like many of my friends are obsessing over how "stupid" the other side is, whatever side they're on and whatever argument they're having. All they can think about is showing them the facts, as they see them.

When you're trying to convince someone to change their thinking, though, it does little good to quote facts or statistics. People will put up their guard against those arguments. The only way to get people to listen with an open mind, or at least an open heart, is to tell them a story. Something personal that brings your points home.

Then again, I've met people who don't seem to care one bit if I tell them the most heart-rending story about, say, an artist working hard against enormous odds to be successful, but if I can make my points personal to the listener, I sometimes gain a little ground.

I was talking to someone the other day about a proposed elimination of the National Endowment for the Arts and the "futility" of funding artists. "They give grants to poets," she said, "yet no one I know even reads poetry anymore, including me."

"Okay, let's go there for a minute," I said. "I get that poetry is not your chosen genre to read, and you have no need for it ninety-nine percent of the time. But can I ask you this: Have you ever attended a memorial service for someone you loved and read a poem the family had chosen for the program?"

She paused. "Well, yes, my dad."

"And have you ever been to a wedding where the bride or groom or pastor chose to read a poem? Or maybe picked out a 'new baby' or graduation card because you liked the stanza inside?"

"I guess."

"So, that means most of the time, many of us will have no reason to give much thought to poetry. But in the most profound moments of grief in our lives, we'll turn to poetry for solace. And in the moments of greatest joy in our lives, we'll turn to poetry to express our happiness. And then, during those most significant events in your life, won't you be glad some poet is out there working hard at her art?"

The woman flashed me a lopsided smile and said, "You got me."

This woman was not stupid, she had just never understood how this art fit into her own life or how her life would be diminished without it.

Generally speaking, people who disagree with us are not stupid (although a few are willfully ignorant). They just have a

different worldview. And that view was formed by personal experience and the stories they told themselves.

In these divided times, we have new opportunities to engage in dialogues that will help us understand each other better. Now is not the time to write people off as "stupid." That'll get us nowhere. Now is the time to tell our stories.

○

YOU'VE GOT TO BE TAUGHT TO HATE

I remember as a child watching the musical *South Pacific* on TV, and being struck by the song "You've Got to Be Carefully Taught." I was one of those kids who cried often about all the suffering and hatred in the world. I never understood why people couldn't just follow the Golden Rule and treat others as they'd like to be treated. I still don't. It seems so simple.

South Pacific was Rodgers and Hammerstein's attempt to confront racism. The Broadway musical debuted in 1949, the movie in 1958. In the show, an American nurse falls in love with a French plantation owner but isn't sure she can accept his biracial children. And a young lieutenant falls in love with a local Tonkinese girl, another relationship that would have been frowned upon at the time. In the song I mentioned, the lieutenant argues that children have to be taught to hate and fear. It doesn't come naturally.

This sentiment overwhelmed me as a child. *Who* would teach their children to hate, I wondered? Certainly my parents had not. What good could come from it? I remember feeling so sorry for kids whose families had burdened them with such heavy and harmful emotions.

And now, as a grown-up, I've seen those emotions rear their ugly heads in the industry I love, the arts. But I've also seen artists confront bigotry, hatred, and fear in their works. And maybe, just maybe, if enough children are exposed to art that challenges hate and promotes love, peace, and understanding, we can serve as teachers too. Maybe some young child will observe our art, as I observed that musical, and question the negative messages being drummed in their "dear little ears."

Art is not the answer, but it could be part of the solution.

○

FINDING COMMON GROUND

The other day, I was sitting at the dinner theater where the seats are very close together. Before the show started, I heard the couple next to me talking with the waitress about whether they should buy season tickets again. After all, a few of the shows in the last few seasons were a little too edgy for them. The gentleman mentioned almost walking out on one show, and I rolled my eyes. I had seen that performance, and while it pushed a certain boundary, it was nothing I would have walked out over. I started criticizing these people in my mind and hoping they didn't renew their season tickets if they were going to be "that way" about it.

Then at the intermission, the woman turned to me suddenly and said, "Can I ask you a question?" I couldn't imagine what it might be. "What was the name of the boy in *Grease*? There was Sandy and…"

Despite myself, I perked up. "Danny. Danny Zuko."

"That's right! I win," she said to her husband. They'd bet each other a quarter to see who could come up with the name first. I joined in on the teasing when her husband accused her of cheating, and then we turned our chairs around and started

talking about the show we were watching. And then we chatted about other shows and how long we'd been coming to the theater. We reminisced about *Sister Act* and all the memories it brought back about nuns and Catholic school. And that made us laugh.

I'm not going to lie and say all my judgments about this couple miraculously disappeared. A part of me still wanted to chide them for walking out on a show, but a bigger part of me realized art is subjective, and they had a right to like and dislike what they pleased. And regardless of where we each fell on the line between conservative and liberal in our theater tastes, we all still loved theater. We supported it with our time and money. We promoted it to our friends. We felt in our hearts it had value in our world.

When you stand on either side of a line, you have to admit there is one patch that belongs to neither of you. It's the patch the line follows. There is always common ground, you just have to be willing to step on it together.

SHOULD YOU TELL YOUR STORY?

My husband and I went to a PechaKucha Night. These events are billed as showcasing "the art of concise presentations." Presenters are allowed to show 20 slides for 20 seconds each and talk about those slides. The presentation advances automatically, so the speaker has to keep up. He or she can share ideas, work, passions, thoughts, just about anything.

I've noticed a growing interest in storytelling lately. Our local newspaper is hosting storytelling events. So is another organization. I've seen more calls for storytellers at open mic nights. And local storyteller groups are attracting new members. Why this sudden interest in sharing our thoughts and experiences in person, out loud, to total strangers?

Chalk it up to our disconnected, social media–addicted, binge TV–watching culture. There are only so many hours you can spend staring at technology devices before you crave the feeling of warm bodies all around you, and the look of recognition and appreciation in a fellow human's eyes.

Storytelling is our oldest art form. It came before visual art and written language. Maybe dance and performance came along with it, maybe it came first. But since the dawn of humankind, we've felt a need to express ourselves.

Stories taught us lessons, showed us how to survive, and helped us feel connected. They also taught us, I suppose, whom to fear and maybe whom to hate. They helped us understand our natural world and the worlds beyond our own. Stories are at the heart of every piece of art ever created.

So, maybe it's natural people are moving beyond telling their stories in blogs and YouTube videos and back to sharing them with people who can laugh or cry or applaud as they speak. They say we Americans are more "divided" than ever. But stories bring us together.

And so, we gather in coffee shops and restaurant patios and college lecture rooms, and listen to people talk about their harrowing climbs up a mountain or the backyard toy they invented or the best advice their mother ever gave them.

"What makes them want to do this?" my husband asked me. "They're not getting paid. They're not trolling for clients. Why tell their stories?"

"Because we are all important. We all have something to say. We all have something to teach. You should do it."

Pause. "Maybe I will."

O

Bursts of Brilliance for a Creative Life

WHAT LULLABIES CAN TELL US ABOUT ART

It's safe to say every culture across the globe has its own lullabies. And that mothers have been singing their children to sleep since time began. If your ancestors hail from a certain country or tribe, you may know the traditional lullabies. Or perhaps your mother made up her own songs. Or maybe she just hummed. But singing while rocking a child comes naturally.

So, imagine my surprise when I discovered that my three babies were choosy about their lullabies. I'd always assumed I would just sing the tried-and-true tunes I'd heard as a child, but when my son was born, he'd have none of those. In desperation, I started pulling all kinds of songs out of my memory banks, and guess which one he liked the best? A song I doubt many of you know, and even fewer of you can sing. It's a wonder I can sing it. It's called "I Still See Elisa," and it came from the movie musical *Paint Your Wagon*, which is anything but a kids' show! In the film, the song is sung (badly) by Clint Eastwood. He's warbling about his lost love. And only to Elisa would my restless son settle down.

My older daughter was an easy baby from the moment she was born. She was perfectly happy just to hear me hum that old standard, "Brahms' Lullaby." But my younger daughter has

always had a mind of her own. She tested and discarded every one of my ballads and ditties, until I finally resorted to a song I'd taught myself by rewinding a recording of a movie about Houdini. It's called "Rosie, Sweet Rosabel" and was written in 1893. Yes, the nineteenth century! Who knows, maybe my daughter had a previous life and remembered that tune in its heyday. But when I would sing Rosie, she would pop her thumb in her mouth and slowly close her eyes.

It's amazing, isn't it, that art is so subjective even babies have their preferences? We are hardwired to love the things we do, and while parents, peers, and community can influence our choices, there is something deep inside us that just knows what we like when we hear it. Or see it or write it or experience it.

So, love the art you love, with no apologies. If you're an adult who likes to read comic books, do so on the subway. Own it. If you're a 12-year-old who prefers Shakespeare, go ahead and quote it to your friends. If your kid loves rap, and you just can't imagine why, let him listen to it. Don't judge. Try it out even. Who knows, maybe someday someone will introduce you to a type of art you'd always assumed you'd hate, and you'll find you like it. Be open, be curious, be accepting. Art is for everyone. It knows no time or cultural boundaries. Make the art you love and engage with the art you love. And if your kid won't sleep, try an old Beatles song. You never know.

Bursts of Brilliance for a Creative Life

ASK THE QUESTIONS THAT MATTER

My daughter did something very sweet this year. She asked all of her parents, siblings, grandparents, and aunts to tell her the names of their favorite books. Then she started to read those books and opened conversations with each relative about the story. If you really want to get to know someone, finding out more about their taste in art is a great way to see into their soul and discover what really moves them.

The next time you're at a gathering of friends or family, skip the conversations about sports or politics or jobs and ask something that goes a bit deeper:

- What song always makes you want to dance?
- Did you ever have a breakup song?
- Which movie made you cry?
- If they made a movie about your life, who would play your mother?
- Which book have you read more than once and why?
- What was a book you thought you'd hate but wound up liking?

- Have you ever fallen asleep while attending a performance?

- Who's the one performer you've always wanted to see live?

- What's your favorite thing to draw or doodle? Can you show me?

- If you could buy any piece of art in the world, what would it be?

- If you could have any talent in the world, what would it be?

- If you could produce one piece of art—any type of art—that would change the world, what it would it be?

Be open, of course, to wherever these conversations take you. Childhood memories may surface, old regrets may show their faces, an item may get added to a bucket list, a spontaneous sing-along or dance-off may ensue. If nothing else, you'll likely feel a new bond to those around you, the kind of connection that only comes when we share deeply about the things that move us. Enjoy!

O

BE THE CHANGE

Recently, for the first time in my life, I've been standing on street corners soliciting signatures for a petition. At first, it was intimidating to approach total strangers, but I reminded myself that the initiative I was hoping to see on the ballot was important, and I trusted other people would see that too.

Most people are polite, even when they turn me down. Several wave me off without a second glance. Only one has been outright rude. The initiative is to help create a Scientific and Cultural Facilities District in our county, which will bring millions of dollars to our area for nonprofits that work in the arts and sciences.

As an individual artist, I won't be able to apply for the grants, but that hasn't stopped me from supporting the district. Why? Because I believe the pot is big enough for all of us. It's my hope that if the nonprofits get access to more funding and can increase their programming, they may include more individual artists in the process. For example, a theater may hire a writer to write a sketch they can take into schools, or the science museum may hire a local artist to create a backdrop they can use at public events.

We all benefit when artists support other artists.

But once in a while, we need to put aside our hesitations and step out of our busy lives in order to champion the things we believe in. Artists are notorious for wanting to lay low, keep to ourselves, and stay focused on our work. Once in a while, we all need to do our parts to raise awareness and funding for the arts.

Gandhi once said, "Be the change that you wish to see in the world." What change do you wish to see? Are you working for it, or just hoping someone else will take up the cause? Someday, we're going to figure this out, how to build a culture that allows artists to earn a fair wage. We will because we're some of the most creative and driven people who have ever walked this earth. And if we work together, someday our kids or grandkids are not going to remember a time when artists couldn't make a decent living. Those will just be stories from the "old days." And we will have been at the forefront of change. Believe it!

Bursts of Brilliance for a Creative Life

GIVING THANKS TO THE ARTIST IN EVERYONE

I finally had a chance to finish watching Ken Burns's documentary, *The Vietnam War*. It was a commitment to watch all 10 episodes, and I'm so glad I did. I'm grateful for Ken Burns and how his documentaries have educated this nation and shown us the very human face of war and history.

Toward the end of the documentary, we are introduced to Maya Lin, the 21-year-old artist whose design was chosen for the creation of the Vietnam Veterans Memorial in Washington, D.C. They mention some of the controversy around her design, and how people said she was too young, too inexperienced, too ethnic, too female to represent the conflict accurately.

Then they cut back to the people they'd been interviewing throughout the documentary, men who fought, and men and women who protested the war. In nearly every case, they said a visit to "The Wall" brought them to tears. Even talking about it on film, they still cried. This piece of art, this "scar in the landscape," healed a nation and deeply moves even those of us who visit it and have no direct association with the war. This artist, whom some found undeserving, stood by her art, and we are better for it.

Today, I speak my gratitude for all artists. Those who do it professionally, and those who do it for themselves or their families.

- I'm grateful for the artists who arrive at their "day jobs" yawning because they were up all night working on their *real* job.

- I'm grateful for the artists who persevere when people tell them they're too young or too old; too uneducated or too knowing; too undeserving or too privileged; too innocent or too jaded to produce their art.

- I'm grateful for the young people who've committed to pursuing their art knowing it's never going to be an easy path.

- And for the artists who take risks or who write and produce art outside of their own experience, even when they're told they shouldn't.

- I'm grateful for the artists who work to the point of exhaustion to meet the demands of success and fame, and all of those who work to the point of exhaustion trying to achieve success and fame.

- I'm grateful for the artists who aren't "very good" but stick to their art anyway. They teach us it's the act of creating that really matters.

- And I'm grateful for the artists who are so talented they set the bar impossibly high. Their work takes our breath away and inspires us to try harder.

- I'm grateful for the artists who are really prophets. And for the prophets who inspire our artists.

- I'm grateful for the children who climb on statues and point at graffiti and take a leaf home and paste it into their coloring books. They don't have to be told to admire art, they just do.

- I'm grateful for the mothers and fathers who read to their children at bedtime and play songs for them on the piano and sit at the table and mold sculpting clay with their kids.

- I'm especially grateful for those who follow their muse, even when it terrifies them to do so.

- But most of all, I'm grateful that even in times of trouble, we can still sing together in church, recite poems at our community gatherings or even our rallies, read books together in our book clubs, and gather around the virtual water cooler to talk about the hottest new movie.

- I'm grateful for those of you who practice the art of medicine, education, innovation, science, agriculture, business, and more. Thank you for sharing your art with us.

In the immortal words of ABBA, "without a song and a dance, what are we?" Thank you, artists, for giving those to us!

O

The Power of Art in the World

THE POWER OF ART

Alicia Garza was upset when George Zimmerman was acquitted of killing Trayvon Martin. She wrote a heartfelt post on Facebook that contained the words "black lives matter." A friend read it and put a hashtag in front of the phrase, and a movement was born.

It's like I tell the schoolchildren to whom I speak: "Your voice has power, but only if you choose to use it." And your art has power, but only if you choose to put it out there in the world! Be generous and prolific with your passion. When the spirit moves you, don't hold back. Don't always wait for the right moment or the right medium or the right channel or the right opportunity.

We can spend all our time looking for the Yellow Brick Road or we can put our creativity out there day in and day out in whatever way presents itself, and the results may surprise us. A single editorial about Santa Claus, for example, is still beloved one hundred years later. A Kilroy doodle from the WWII era has become a graffiti icon known worldwide. An eye-catching poster helped land a man in the White House.

Sometimes the results are not so profound, yet still impactful. A while back, my physical therapist was writing a book for her clients. I shared a story that she wound up using in the book. It was a very personal story and emotional to reveal, and I had nothing to gain from telling it other than helping my friend and speaking my truth. I wonder now how many people have read that segment and whether it has helped them heal. I may never know the answer to that question, because we can't always see the threads that tie us all together. But they are there. And they are strong. And they move mountains.

○

WHEN TRAVELING, WHAT ART DO YOU SEEK OUT?

One of my favorite things about traveling is getting to appreciate all the history, architecture, art, crafts, culture, and food of a country or region.

It's funny, isn't it, when we travel—unless we're swimming in the ocean or hiking in the woods—we're often to be found exploring art museums, taking selfies next to famous sculptures, admiring centuries-old cathedrals and castles, listening to music in local pubs, and the like. We stand in line for hours for a glimpse of the Mona Lisa or a chance to climb the Eiffel Tower. We plunk down our hard-earned cash to see a Broadway play or attend an opera in Mexico City. We make pilgrimages to the places where great writers once lived or worked. In other words, even on vacation, we seek out art. And through art, we understand the cultures we're exploring and the people we're meeting and even the food we're eating.

And then we bring that art home. We bring it home on T-shirts and coasters and postcards and coffee mugs. We bring it home in books and CDs and on our camera rolls. We show it off to everyone who asks what we bought on the trip. We show them jewelry we purchased from an artisan's stand near the beach

and a watercolor we picked up from an artist who'd set up her easel in a town square, and a piece of handblown glass from the factory tour we took that one afternoon.

And we bring the art home in our stories. We talk about the dramatic looks on the faces of the Flamenco dancers, and tell a story about a performance artist who posed as a statue and fooled us until we walked right up to him, and we joke about a poet who could make up funny poems on the spot in that café by the fountain. We retell the stories we heard about how the great architect Gaudi died penniless in a tram accident and how Hemingway and F. Scott Fitzgerald first met at a bar in Paris. Somehow, we know people will be interested to hear about the ups and downs in the lives of the artists we all adore.

Art matters. And though the respect paid to artists varies greatly by country, one thing is consistent: every country, every region, every city uses its art to attract visitors and to say, "See this art? This is us. This is who we are. Come be one with us."

ART AMIDST THE TUMBLEWEEDS

I just returned from an author school visit with my good friend and fellow author Natasha Wing. We drove nearly four hours through sagebrush and tumbleweeds to reach the small town of Eads, Colorado, where we were greeted with much fanfare. The children and the art teacher had made posters and hung them throughout the school and in the local post office. The kids had also prepared gifts for us and eagerly ordered our books in advance.

When I was conducting a writing workshop with the sixth to eighth graders, I asked, as I always do, who among them liked to read. To my surprise, every hand in the room shot up. When I asked about their favorite books, they didn't quote the usual titles, *Harry Potter* or *The Hunger Games*, they named books even I had never heard of. When I asked how they found those books, they pointed to their English teacher.

Later, I asked the third-grade teacher how it was that so many of the students had come to love reading. She smiled and said, "Well, there's not much to do around here." But it was more than that. Though the teachers at Eads Elementary are saddled with the same time constraints as their colleagues all across

the country, Mrs. Gifford told me she finds time to read to the kids every day and to help them select books to take home. The school has built a culture around reading.

Those of us who live in cities sometimes, shamefully, make fun of small-town living, and those of us who work in the arts often feel sorry for country kids because they don't have as much access to concerts and live theater. But these kids were not just observing art, they were creating it. Maybe the key for all of us, everywhere, is to construct an environment that supports creativity in our children. We can set aside a certain hour every day that is technology free and give our kids the chance to inquire, and create, and imagine. Instead of overcommitting them to every sport or activity in town, we can make sure there is at least one afternoon each week for them to just be kids. Because truly, most of the time, a love for the arts and innovation starts with a bored kid who amuses himself by creating something new. And from that, a lifetime of exploration begins.

HOME IS ALSO WHERE THE ART IS

I recently returned to my hometown of Boise, Idaho. My cousin and aunt were visiting from Houston and St. Louis, respectively. Both enjoy great architecture and history, so we took them to the old section of Boise near downtown. We admired the architecture inside and outside of St. John's Cathedral, the Capitol Building, the Egyptian Theatre, and Bar Gernika in the Basque Block.

I grew up regularly going into and driving past those buildings. I'd taken a school field trip to the Capitol Building and later made deliveries there for the law firm for which I worked. We went to many a movie at the Egyptian. It was my favorite theater in town! And I'll never forget the beauty and wonder of Midnight Mass at St. John's, the choir's hymns rising to the painted ceiling. But it's been years since I walked into any of those sites, and you forget.

You forget to notice the magnificence of the art you pass every day. The stained-glass windows in a local church, the wall paintings in a movie palace, the wood carvings on the walls of an old bar. We revere these places because some architect took pains to design a building that would bring pleasure to our eyes and ears as well as provide a roof over our heads.

All around you, on every street corner and down every alley, is the evidence of some artist at work. A decorative iron fence, a statue in a courtyard, a carved window box, a song drifting through an open back door. Like the sky above and the flowers that grow, they create a landscape that lifts the spirits.

Next time you go on a walk through your same old neighborhood, take your ear buds out, lift your gaze from your phone, quiet your scattered thoughts, and just notice the art that surrounds you. You may be surprised by what you see and hear.

○

LIFE CAN ONLY BE WHAT YOU MAKE IT TO BE

When I was growing up in Boise, there was a local singer named Steve Harmon. He sang at our church, and he also recorded a record called *Stand by Him* back in 1974. I grew up listening to that album. My mom played it often. You've never heard of it? I'm not surprised. I'm not sure that Steve was very well known outside our local area.

But Steve had a song called "Life Can Only Be," and all these years later, the words to that song still run through my head on a regular basis. *Life can only be what you make it to be.* I think maybe I loved that line because it was the first time I realized as a kid that life was not just something that happened *to* you, and it was not just something dictated by your parents and teachers, it was something you could influence and, in some ways, control. Whatever did or did not happen in your life, was up to you. That was at once frightening and liberating, but mostly exciting.

Those words pop into my head now, often in the early part of the day, whenever it feels like things are not heading in the direction I want or when I'm feeling overwhelmed or unsure. They are a gift from a man who has since passed away and who

never achieved fame or fortune from his music. I wonder if he's sitting on the other side feeling pride in the fact that his art, his music, keeps me on course. That his words changed one life.

I wonder if he feels that is legacy enough.

GIVING YOUR MOST PRECIOUS GIFT

Today I had the pleasure of attending a fundraiser for one of my favorite local charities. As always, I was in awe not only of the stories told by the families who benefit from the services, but by those of the volunteers and staff who shared how much their work means to them. We are fortunate to have so many generous souls on this earth.

All of that got me thinking about my own interest in philanthropy. I was that child who would lie awake at night worrying about the poor and starving children of the world and wondering how I got so lucky. I was sure if I thought long and hard enough, I could figure out how to help them all. So, what was it that influenced me at such an early age to care so much about the plight of others? Truthfully, it was the hard work of all those writers, reporters, and photographers who brought the news into my living room every night. It was those heartbreaking images and well-told stories that haunted me.

We artists are in a unique position. We can and should donate our time, money, and expertise to causes we support, but we have something else to give: our talent. Because when an artist or playwright or musician or writer portrays pain or illness or

The Power of Art in the World

despair in their work, they allow the rest of us to *feel* what it must be like to be starving or homeless or ill. They take us into the heart of war. The soul of misery. They allow us to look into the eyes of suffering. But artists also enable us to feel the joy of human connection, the achievements of those who are challenged, the absolute love of a parent for his or her child, the small miracles of everyday life. Thank you to all of the artists whose work has challenged, changed, or affirmed our views of humanity, and thank you for making us feel both troubled and determined. May we all use our gifts to make a difference.

○

MY REGARDS TO BROADWAY

It's impossible to talk about Broadway musicals without sounding corny. So, let's acknowledge that and move on.

I've been obsessed with musicals for as long as I can remember. Why? Because on Broadway, the dreamers were the heroes. And they were not head-in-the-clouds dreamers, they were people who took action and changed everyone around them in the process. In a musical, you were lost without a dream.

I sometimes imagine my life playing out with a Broadway score behind it. And I wonder if I ever would have had the guts to quit my job and become a writer if Don Quixote hadn't convinced me it was noble to believe in "The Impossible Dream." I wonder how many risks I've taken because the song "Seasons of Love" constantly reminds me that our lives are made up of precious minutes that should never be wasted. As a good little Catholic girl, when a nun, of all people, insisted we "Climb Every Mountain," I knew God himself wanted us to reach for our highest aspirations. (I told you this was going to be corny.)

In musicals, the rules were made to be broken, and that was often shown through the metaphor of dance. A Siamese king could waltz with a British schoolteacher, a stodgy old profes-

sor could spin with a flighty Cockney girl, a Polish boy could cross a gym to dance with a Puerto Rican beauty. Whether at a formal ball or a country hoedown, the people in musicals pushed the boundaries.

Even when a musical ended in heartbreak, the actors were played off stage by a soaring score that reminded us that, though they had lost it all, at least they'd *had* it in the first place.

While the adults around me filed out of the theater saying things like—Wasn't that good? Wasn't her dress lovely?—I was jabbering all the way to the car about all the things I was going to accomplish, the dreams I was going to pursue, the rules I was going to break.

You can call it all schmaltzy, and I won't argue, but there's still a part of me that rallies every time I hear a stirring Broadway tune, and what's wrong with that? Those oh-so-clever songwriters knew that sometimes we humans just need to believe.

○

I'M NOT EMBARRASSED

In my industry, there's been a lot of talk about Ruth Graham's article in *Slate* suggesting adults should be embarrassed to read young adult titles. Never mind the slights to YA authors, let's look at what else she says:

She argues we should challenge ourselves with a higher form of literature and leave the stories written for children to children. She says if adults keep reading YA books, children will stop, because they don't want to read the same books as their parents. A possibility, but not one that I've seen played out in my household. My teenage children and I often read the same books, and some are YA. There's genuine pleasure in having a meaningful conversation with my kids about a book we've all read. And that doesn't change whether the novel is *The Fault in Our Stars* or *Pride and Prejudice*. In fact, back in the heyday of Harry Potter, which is—gulp—a middle-grade series, my kids were discussing the books not only with my husband and me but also with their grandparents. A multigenerational appreciation of a good story. Period.

As an artist, I would hope people will always be able to recognize true talent and skill. I would hope we *never* stop challeng-

ing ourselves to understand the genius of a Shakespeare or a Mozart or a Hepburn, but that we always make room for the countless artists who fall below that mark. To be honest, I'm more embarrassed when I don't "get" a highly acclaimed piece of art than I am to carry around a copy of a YA title.

To me, the definition of art is something that moves or inspires us. If it leads you to see beauty in your world, if it challenges your prejudices, if it pushes you toward action, if it makes you feel happiness or outrage, if it stirs you to want to learn more or see more or hear more, then the artist has succeeded.

○

LOST GENERATION FOUND

I recently returned from a trip to Paris with a friend. We went on a literary walking tour in which our guide showed us the pubs and bistros where some of the most famous writers of the early 20th century gathered to write, debate, drink, celebrate, and argue. Writers like Ernest Hemingway, James Joyce, Ezra Pound, Gertrude Stein, F. Scott Fitzgerald, and more, who were referred to as the Lost Generation. And at the center of their circle sat Sylvia Beach, owner of Shakespeare and Company bookstore and their staunchest supporter.

Like most people, I've always romanticized the image of all those geniuses gathered together, but truthfully, these people, for all their talents, were pretty flawed individuals. I'm not even sure I would've wanted to count some of them as friends. In many ways, they were more interesting than the characters they created.

When I was young, I thought to truly make it in the writing world, I'd need to move to New York City. And I accepted that if I wasn't willing or able to do so (which I wasn't) I would probably never be famous. Though I know it's ridiculous, I still sometimes wonder what would have happened if...

But for every writer or actor or dancer or singer or artist who has moved to New York and made it big, there are thousands who did not. And for all the artists who live and work in their hometowns, there are a handful who make it big without leaving their state.

Genius can thrive anywhere, and talent will attract talent. I live along the Front Range of Colorado, and we have a higher than average population of artists of all types. Why? What draws us here?

A friend of mine once hypothesized artists are drawn to the same places once considered holy by the indigenous populations. Is that it? Is there an aura of something bigger that lingers in these places? Or are the rich landscapes just *that* inspiring?

I'm not sure how we artists find each other, but we do. And it doesn't just happen in Paris or New York. We're surrounded by more talent than we realize, we just have to seek it out. And together, we grow stronger and better and braver. We find our Sylvia Beachs, the people who love and support our work.

"Live the full life of the mind, exhilarated by new ideas, intoxicated by the romance of the unusual," Hemingway once said. And here's the beauty of that quote: we can follow his advice anywhere.

Bursts of Brilliance for a Creative Life

THAT'S GENIUS

The other day, I was watching an interview with Lin Manuel Miranda, the creator and star of the megahit Broadway show *Hamilton*. I was recently in New York and my hotel was across the street from the theater. It was torture walking by each day knowing I'd have to kill someone in order to get a ticket. How I'd love to see that carefully selected original cast on a Broadway stage. How I'd love to witness genius.

Like most people, I'm fascinated by genius. Everyone from Albert Einstein to Beethoven. From Marie Curie to Adele. I wonder constantly what it must be like to be so gifted, to be a hair's width from perfection. Oh, I realize most geniuses have problems of their own, but they also have the ability to change the world. What must it feel like to have that power?

I know, I know, there's genius in all of us. Isn't that what I espouse in this very book? That we're all brilliant at times? But realized genius is rare. It's part inborn talent, part unfailing instincts, part unflinching nerve, part relentless curiosity, part rebellion, part passion, and part burning desire to create something new or better.

It's true, I think, that all of us have that potential, but few of us are willing to fully pursue it, because true genius also requires a bit of obsession. And with obsession come sleepless nights, long workdays, agonizing doubt and frustration, and self-criticism. And frankly, these are things many of us would wish to avoid.

So, we jump to our feet and applaud wildly when we witness genius. Why? Because we know it was hard-earned and it is rare and beautiful and we celebrate that. But also because we gain inspiration just from being close to genius. We feel all kinds of hope, and maybe part of that hope is that someday something will light us up and we too will find the passion and energy to release our inner genius.

○

SHOULD AN ARTIST EVER GET POLITICAL?

You know how sometimes a Hollywood actor speaks out about a cause, and the critics shout him down? "She gets paid to act," people say, "not spout off about her opinions." There's a double standard when it comes to artists and politics. The message we receive is we're "lucky" the public allows us to do our art, so we should shut up and do it.

Does art have a place in politics? Well, the political cartoons of the 1700s helped turn our young nation against an unjust king. And a certain pamphlet by Thomas Paine galvanized the cause. You could debate whether *Common Sense* counts as art. It was a political argument set to paper. But any person who's ever picked up a pen recognizes the hard work that went into great lines like, "a long habit of not thinking a thing wrong, gives it a superficial appearance of being right …"

A novel, *Uncle Tom's Cabin*, is widely credited with casting a new light on the issue of slavery for a public that had turned a blind eye. During World War II, propaganda posters reminded women "We Can Do It" and men that Uncle Sam "Wants You for the U.S. Army." During the Civil Rights Movement, songs like "People Get Ready," by The Impressions, were written with the intention of inspiring people to join the struggle.

So, what's an artist to do? If we take a political stand, we risk losing fans and followers and sales, and that can be very scary, especially at the outset of your career. Worse, we risk losing friends. We risk being labeled, and having that label carry over to views of our art. We risk people reading politics and agendas into everything we create. And if we are further along in our careers, or possibly famous, we risk people expecting us to take a stand all the time.

But if we don't speak up, if we don't use our talents to further the causes we believe in, we fail to influence change in the world, we stifle a passion in ourselves, we cave into fear. Artists have a unique ability to paint the world, and to help people see injustice. It is the artists who often take on the bullies, from the ones who run local police stations to the ones whose names are writ large on the companies they own. They do it not with guns, but with pens and guitars and paintbrushes. People, Get Ready.

○

Bursts of Brilliance for a Creative Life

DID BOB DYLAN DESERVE
THE NOBEL PRIZE IN LITERATURE?

In 2016, Bob Dylan won the Nobel Prize in Literature. Opinions among writers on the internet were certainly divided. Some felt there were already plenty of accolades and awards for songwriters, and that Dylan had achieved more than his fair share of fame and fortune from the music industry, and that songwriting is not literature. Others felt that Dylan's lyrics are, indeed, poetic and even influenced by classic literature, and that good writing is good writing, period.

I'll admit my first reaction was mild dismay. I don't disagree Dylan has made a lasting and unique contribution to art and culture, and he certainly has a large and varied volume of work, but it's true he has been justly and aptly recognized for that in numerous ways.

While the glorification, appreciation, and consumption of music remain high, the same cannot be said for literature. Fewer books are being read and purchased, and author incomes are down by more than 20 percent in the past decade. Celebrating the contribution of authors to world culture seems important

right now. I'm feeling kind of protective lately of the few ways in which authors can establish their presence.

But in thinking more about it, I realized, as with everything else, the more we separate ourselves, the weaker we become. I've long been a proponent of collaboration between the arts. By doing so, we not only learn from each other, we expose our audiences to different art forms. If Dylan's win helps music lovers take an interest in the Nobel Prize in Literature, maybe they'll seek to read some of the other winners. And if someone is doubting whether songwriting is a "real art," this award may give him the confidence to pursue that interest and maybe even to take it more seriously.

On the flip side, maybe his win also gives authors permission to think outside the box to discover for themselves the true meaning of "literature," and that could lead to some exciting new forms.

Dylan's win has us talking, partly because he *is* famous and his win *is* controversial, and any time we talk about art and culture, that's good.

Maybe it's time all artists admit we're influenced by each other and we cross the lines all the time. I know writers whose story ideas were sparked by a lyric in a song and musicians who took a friend's poem and set it to music. I know painters who were inspired by a TV character and actors who based a performance on the nuances of an eccentric artist.

The Nobel Prize is big, but it's just one committee's opinion.

I've read award-winning literature that made me yawn and never-awarded books that changed my life. So, debate it all you want, then get back to producing your own art and share it across the channels! Because that's what really matters.

O

WHEN YOUR ENERGY RISES, TIME EXPANDS

I get it now. Finally. It's only taken me 50 years. People often say we must make time for ourselves, but I never really understood why. I mean, I kind of got it and sometimes I did it, but I'm a busy person. There are days I barely keep up with the chores and the work and the obligations. Who has time for hobbies or art?

But the fact is, there are many parts to ourselves. We feed our bodies, our intellects, our spiritual beings, but we neglect to feed our imaginations. There's an artist inside all of us. Whether your art is writing or music or crafts or gardening or cooking, it is the space in which you express your creativity and originality, and experience passion and joy. And what does that lead to? A rise in energy—energy we then take into our lives and work, enabling us to do much more and do it far better.

With a rise in energy, we become more awake, more at ease, more confident, and happier. It is, therefore, imperative to the success of our businesses, the proper running of our households, and the good work we do in our communities that we take time to practice our art.

Sometimes it's not even in pursuing our own art that we find that energy surge. It can also happen when we engage in more

indirect ways, like going to a movie, listening to a new CD, or reading a book.

I remember the first time I saw *Les Miserables*. I was 21 years old and studying for a semester at West Chester University outside of Philadelphia. Some friends and I drove into the city to see a traveling production. When we left the theater, we spontaneously gathered in a tight circle on the sidewalk and held hands (guys and girls together) and literally jumped up and down. There was an energy running through each of our bodies that was just short of euphoria, and when we joined hands, it amplified. In that moment I thought, "If something as amazing as that show can exist in the world, we can do anything! We can change the world." That's how we felt in that moment: powerful, motivated, moved, and energized. I rode that wave for days as I struggled through my homework and classes. Anything seemed possible.

It is not decadent or selfish to pursue art; it is necessary. Don't do it just for yourself, but for the people you serve. Take a cold, hard look at the things that currently fill your time and figure out which of them could go to make more space for the things you love to do.

And then watch: as your energy level rises, you may find more time for your work and responsibilities, or you may find better, more creative, more original, more productive ways to move forward.

Trust that if you give time to your art, time itself will expand to enable you to do more of all the things that matter.

OF POETRY AND ART THAT
DWELLS IN YOUR HEART

I invited two poets, Veronica Patterson and Lisa Zimmerman, to speak to one of my writing groups. They talked about how poetry predates written language and how it's in all of us. They pointed out that little kids speak naturally in analogies. For example, when you ask them how something felt, they say, "It felt like when my uncle ran over my skateboard." And they talked about how many of us remember poems and nursery rhymes from as far back as childhood.

"We say we know them 'by heart,'" Lisa said. "Because that is where we keep our poems."

I've been learning lately the soul leads the heart, and the heart leads the mind, and the mind leads the body. When we are doing our soul work, we feel it in our hearts. And our minds and bodies engage to support our passion. There's sometimes no reason to write poetry, or anything else, except that our souls demand it. And when we do the work we are meant to do, that passion goes out in the world and touches or teaches.

As they were talking, I thought about one of the poems I've had memorized since my late teens. It's Shakespeare's "Sonnet

29." I heard it first on a favorite TV show, *Beauty and the Beast*, and loved it so much I committed it to heart. I thought then, of course, it was a poem about romantic love. But the other evening, as I watched those two poets inspire everyone in the room, I realized I could dedicate that poem to my fellow writers. The ones who lift me up and keep me going when doubt and insecurity, frustration and envy set in. Poems, like all art, can mean just what we need them to mean right when we need them most.

Here's the sonnet. I dedicate it to all my friends who follow their art and all my friends who encourage others to follow theirs:

SONNET 29
by William Shakespeare

When, in disgrace with fortune and men's eyes,

I all alone beweep my outcast state,

And trouble deaf heaven with my bootless cries,

And look upon myself and curse my fate,

Wishing me like to one more rich in hope,

Featured like him, like him with friends possessed,

Desiring this man's art and that man's scope,

With what I most enjoy contented least;

Yet in these thoughts myself almost despising,

Haply I think on thee, and then my state,

(Like to the lark at break of day arising

From sullen earth) sings hymns at heaven's gate;

For thy sweet love remembered such wealth brings

That then I scorn to change my state with kings.

○

ART AND THE BUTTERFLY EFFECT

The other day I was reading a book set in World War II America. Prominently shown in the "Recommended Reading" section at the back was my own book, *Dancing in Combat Boots*. What an unexpected thrill. I showed it to my usually low-key husband, and even he was impressed. A few days later, we were visiting my in-laws in middle-of-nowhere, Idaho, and a distant relative said to me, "I saw your name in the acknowledgments of a book I'm reading. The author seemed so grateful for your assistance!" It was a different book, by the way. Another unexpected surprise.

As artists we think constantly about our own work, and part of us (even for those who deny it) secretly dreams our creations will be the next big thing. But for most of us, our artist journeys will consist of hard work, long hours, modest livings, and a modicum of recognition or success, and for that we will count ourselves lucky.

We don't think very often about all the ways our art impacts others. And many of us will never know. If my book inspired another artist to do her best work, how great is that? If my guidance helped another author share his message with the

world, how great is that? If someone writes to tell me my quote in a magazine article gave her the courage to start writing again, how great is that?

I've said it before: we'll never know the full impact of our art, and that's okay. If there is such a thing as the "butterfly effect"—and sometimes a small change can make a large difference—it only stands to figure that sometimes *we* are the butterflies.

○

PART VIII

Taking It to Your Highest Level

WHAT IS INTUITION, ANYWAY?

A colleague recently suggested I write a post defining intuition. After all, I speak often about the importance of following our inner guidance. My first thought was, "That's a bit of a lofty suggestion. Who am I to explain something as deep and disputable as intuition?" My second thought was, "There you go, doubting yourself again. Why not you?"

I mean, it's not like I don't have an intimate acquaintance with intuition. So do you. Everyone does. Spend any time with a baby, and you'll realize very quickly that intuition is born into us. And even those who don't equate intuition with a higher source and prefer to think of it in a more practical way can admit they've experienced the hair rising on the back of their neck, or a tingle running down their spine, or butterflies in their stomach.

So, what is intuition? In simplest terms, I think it's our Higher Selves talking to us. That's why sometimes it sounds like a literal voice in your head. You *hear* it. "Don't walk down that street. Don't talk to that person. Take that offer. Tell her you love her." Other times, it's nonverbal communication, a nudge forward or a hand pulling you back. Our Higher Selves speak

to us in our dreams and in our daydreams. When we're little children, we speak back. Our parents say we are chatting with our "imaginary friend," but we know better.

Our Higher Selves speak loudest in that moment when they present an idea or a desire that takes our breath away. We *know* that's what we're meant to do, until we start to question it. "That's crazy," we tell our Higher Selves. "I can't. It would take too much time, money, effort, strength, courage, skill. I don't have any of that." How easy it is to ignore our inner guidance and, therefore, negate it.

Interestingly, as a society, we parcel out intuition, as if we can't all have it in the same way. We mostly agree that every living being has instincts. That appears to be scientific fact. We acknowledge that everyone gets a hunch or a gut feeling now and then. We can grudgingly admit that some people have a sixth sense from time to time. And maybe it's possible a few people have clairvoyance or second sight, if there is such a thing.

We love stories of people who acted purely on intuition and succeeded, and then we try to uncover other factors that led to their success. They must have been in the right place at the right time, we assume, or had access to knowledge the rest of us didn't. When someone acts on instinct and appears to fail, we say, "Well, they should've done more research, collected more data, consulted with more experts. How silly to just dive in."

Bursts of Brilliance for a Creative Life

So, how do we learn to trust our intuition, especially if it's telling us to do something crazy, like quit our jobs to become an artist or create a work of art that might meet with resistance? First, we need to believe what we're feeling is real and in our highest interest. Our intuitions are there to guide and protect us. Then we need to let go once and for all of the concept of success or failure. Because doubt and fear just hold us back. Then we need to move forward knowing we're not alone. Our intuition is constant. Our Higher Selves are not going to set us on a path and then abandon us. They're going to be there all the way. All those old platitudes are true; all you need to do is lean into your instincts, trust your gut, listen to your heart, have faith in your guidance, and follow your destiny.

I know it isn't always easy, and I can't promise you won't have some regrets along the way; we're human after all. But I suspect those regrets will pale in comparison to the greater unhappiness you'll feel if you ignore that voice inside you and fail to heed your Higher Self's call. More often than not, it's the things we *didn't do* we regret, not the things we did.

○

HOW TO BE ONE WITH THE UNIVERSE

As a child, I never pulled a leg off a grasshopper or a wing off a bee. I never burned an ant with a magnifying glass or kicked a dog for barking. I was that kid who named our plants and urged them to grow. I named our cars too and was furious with my dad when he sold one of our sedans without giving me a chance to say good-bye. I knelt backwards in the backseat of the car chatting with the moon, whom I called Moonie. He was my friend. I knew that because he followed me everywhere.

I was that child who cried at night because children were starving in Ethiopia while we had a grain surplus in America. I had sleepovers with my guardian angels, and Jesus was that friend to whom I could tell all my secrets. Mother Mary was my second mother. And God? Well, God sent his Holy Spirit to fill me up in the confessional, so I wasn't afraid. God had my back, even when bad things happened. And he had everyone else's back too, whether they were Jews or Muslims or Buddhists. It was that simple.

It's not hard to be one with everything when you're a child. It's not hard to see how it all fits together: humanity, nature, science, art, religion, the cosmos. It's not difficult to believe in

the divine or in magic or in imagination. And then we grow up and we begin to ignore or reject that voice of our Higher Selves. We have to "work" at being one with everything. We have to read books on the subject and attend lectures. We lose faith, even in ourselves. We no longer believe anything is possible and that *everything* is relevant. We question it all.

But deep inside us dwells that child, the one who believes with all her heart we are capable of great things and that everything we create—if it's created for good—is important and deserving.

That ability to believe is not something we need to "develop," it's something already inside us. We just need to feel into it again and know without doubt being one with the universe is as easy as seeing everything and everyone as your equal. Only then can you be truly open to anything. And with openness will come your very best art.

O

TRUSTING MY PATH

I have a tendency to work too much. My friends tell me to slow down, take more naps, spend more time outdoors, and so on. I'll drop some projects, step back from some roles, say no to some opportunities. And for the first few weeks, it feels great. I have time to read books again, watch TV with my husband, and have coffee with friends. I feel like maybe I've returned to my true self...until I don't feel that way.

I'll start to feel antsy and as if my productivity has suffered. Apparently, I need a certain amount of chaos and loads of deadlines in order to accomplish more. What's that old adage? *If you want something done, ask a busy person.*

But I think a bigger question is at play here. Now that I'm entering a new phase (the empty nest era), I'm wondering if the time has come to kick back and enjoy life, or do the opposite: shift things into high gear and do something *big*.

When I was a child and people asked me what I wanted to do when I grew up, I'd say, "I'm not sure, but I know I want to help people. I want to make a difference." I had this abiding certainty I was put on this earth to do something great. People would say, "That's cute, kid, but not everyone can be presi-

dent." They told me just being a good person was enough, and I think that's mostly true.

But what if those feelings I had as a child were not passing fancy? What if that quiet voice of my intuition was speaking my truth? What if I *was* put here to do something important and I knew it the way kids know so many things we dismiss? Is it arrogant to think it? And if I give myself permission to believe it, does that mean I'll have to go back to being crazy busy all the time? Can I change the world without changing the life I love?

I have a friend who says, do what you want to do right now, always. If you want to sit outside and gaze at the clouds, do it. If you want to change the world, do that. In other words, throw all the rules out the window, throw out all the judgments and self-criticism and analysis, and just do what your heart is calling you to do in that moment, without question.

Maybe I do know why I'm here, I've just forgotten. Maybe if I stop trying so hard to figure it out, it will come to me, kind of like that song that's on the tip of your tongue, but you can't remember it until you give up trying. And it might come on a relaxing walk *or* in a focused meeting with a colleague. I'm not going to worry about that anymore. I've realized I don't need to look for my path. I'm already on it. I just need to trust where it leads.

○

Bursts of Brilliance for a Creative Life

WHATEVER YOU WILL, WILL BE

I've been thinking lately about all the messages I received as a child, all the things society wanted us to believe that never felt totally right to me, yet I accepted them. Why?

For example, when I was a kid, my mom loved the Doris Day song, "Que Sera Sera." In the lyrics, the young girl asks her mother what the future holds. Will she be pretty, or will she be rich? (I know that sounds a bit shallow now, but go with me.) The mother responds, "Que sera, sera. Whatever will be, will be."

There's another version of the song I liked a little better, in which the girl asks her teacher what she should try. Should she paint pictures or sing songs? The teacher tells her the same thing, "Que sera, sera." Part of my young heart was always thinking, "Why can't she do both? Why does she have to choose between the two? If she wants something, why can't she just make it happen? Why isn't her teacher encouraging her to follow her dreams rather than saying, 'Sure, honey, you might be good at those things, you might even be ambitious, but it's not really up to you whether you succeed or get what you want. It's up to the whims of fate.'" And why did I believe that too, just because my mother loved that song?

An expression like that really lets us off the hook, doesn't it? Any time we fail (even if we didn't really try) we can comfort ourselves by saying, "It wasn't meant to be." And other people can offer that phrase as comfort *to* us, because what else can they say when we're hurting?

What if instead of telling the child in the song her hopes were only hopes, the teacher had said, "Whatever you will, will be?" How might that have changed things? Would the child have then thrown herself into becoming the best painter or singer (or both) with full confidence and no back-of-the-mind fear that what she wanted most might be taken from her? What if every time something went wrong for our kids, we didn't say, "Well, at least you tried," and instead we said, "You're doing it! You're living your dream. Keep going."

For a while I tried telling myself, "It wasn't meant to be *yet*." It felt far less defeatist and a bit more evolved to phrase it that way. I was proud of that thinking. But that's also surrendering.

Now I'm telling myself, "It *is* now. I *am* living my childhood dreams. I am that girl who grew up to be both a painter and a singer (figuratively), and I'm doing it well. I haven't reached all my goals yet, but I'm moving toward them. Always. Every day. And that's success. The journey, the effort, the learning, the growing, the living. This *is* my bright, shiny future. Right now. And tomorrow, if I want it to be. And the day after. The future doesn't choose when/if I stop. Only I do. Therefore, whatever I will, will be.

What do you choose?

Bursts of Brilliance for a Creative Life

HAVE YOU LISTENED TO YOUR
INNER COACH LATELY?

My brilliant friend Sandy Scott recently sent out some great advice in her newsletter about ignoring your inner critic and focusing on your inner coach. She describes the qualities of the inner coach as curious, quiet, connected to the head and heart, generating new thoughts, and full of love. Pretty much the opposite of the inner critic. I've read lots of articles about how to tame my inner critic, but nothing that suggested I might also have an inner coach. That was encouraging.

I started thinking about times when I'd listened to my inner coach versus my inner critic and discovered something interesting. Many of the occasions I remember feeling the most confident and capable were instances when my outer critics were all doubtful. Those well-meaning friends, colleagues, or family members told me not to proceed with something I wanted to do and warned me it would never work. And once they started piling on, my inner coach took over. She boosted me up and said, "Don't listen to them. They have no idea what they're talking about. You know what you can do, so do it." And I did.

Conversely, many of the times my inner critic gained the upper hand were occasions when my outer coaches were actually cheering me on. "Oh, you'd be great at that," they said. "Go for it. This is perfect for you." And somehow, the pressure of their confidence in me turned on my inner critic. "Don't listen to them," he said. "They're giving you too much credit. They're just projecting on you what they'd like to see. They don't really believe you can do it."

Isn't that odd? You would think success would come when our inner coaches lined up with our outer coaches, but that doesn't appear to be necessary. And you would think failure would be assured when our inner critics lined up with our outer critics, but that doesn't seem to be true, either.

Really, in the end, the only voice that truly matters is that of your Higher Self. And if you read the definition of Higher Self, it sounds an awful lot like the way Sandy described our inner coaches. Sounds to me like your inner coach and your Higher Self work in tandem.

So, the next time your Higher Self gifts you with an idea that feels *so* right, don't doubt it. Reach out for that inner coach. Picture her standing by the finish line urging you on, and then start running.

O

WHAT IF?

What If? My two favorite words. They've spawned every creation since the dawn of time.

The poet asks "what if?" before he puts pen to paper; the politician asks "what if?" when she's proposing a new bill; the humanitarian asks "what if?" when he's imagining a better world; the scientist asks "what if?" when she's tried everything else.

What If gets us unstuck. It pushes us forward. What if you were to quit that job you hate and take the one you want? What if you committed to that person you love? What if you stopped waiting for the perfect time and had that baby now?

What If leads to breakthroughs and paradigm shifts and whole new philosophies. It brings people together: "What if we could find a way to compromise? What if you tried this and I tried that?"

What If challenges old beliefs: "What if the world is not flat? What if slavery is not sanctioned by the bible? What if women really did have the right to vote?"

What If fires artistic expression: "What if I painted my poppies green?" or "What if I wrote a short story with nothing but dialogue?"

And What If doesn't need to be taught. It's our birthright. Even toddlers get it. "What if I put this teddy bear in the snow to turn him white?"

What If is what this world needs right now. We need people to stand up and say, "It's only 'the way it is' until we decide to change it."

And what if that person were you? Fill yourself with What If and see what happens.

○

WHAT MAKES YOU HAPPY?

The more I study and learn about how we can access our Higher Selves, the clearer it becomes our purpose in life is to seek happiness. Why? Because when we're happy, we raise the vibrations in our own lives and in the world. When we're content and at peace, we're most likely to hear our inner and divine guidance. And when we're having fun, our energy levels increase to provide us the stimulus we need to create and imagine.

This is a realization that has not come easy to me. I was raised to believe happiness exists in special moments only, and the rest of life is hard work and toil and challenge. I was taught you could have a few things that made you happy but couldn't hope for more than that. I was instructed to look sideways at people who seemed mostly happy, because they were clearly kidding themselves.

The old me would have read this line by Sonia Choquette, "The best thing you can do for others, for yourself, and for the world is to be happy," and scoffed. Focusing on my own happiness would have felt so selfish to me then. But now I realize it's not about being happy for my own sake, it's about being happy so I can give more!

I think that's why the gods gave us art. They knew music, dance, art, and poetry would lift our spirits and raise our energy. They knew when we laugh and sing, dance and hug, our joy attracts more joy. They knew life was hard, and it wasn't possible to be happy all the time, but even in our grief, we'd find solace in shared expression. That's why we giggle when someone tells a funny story at a funeral or rock someone in our arms and hum to them when they're feeling low. Light, love, joy, kindness, generosity, care, and empathy are always with us, even when we're most down. Even in our darkest moments, art, expression, and connection hold us up.

I've always insisted I love my work, but that hasn't always been true. Often, I've done things that did not make me happy because I felt I should. I'm done with that. I'm putting my faith in knowing I'm at my best not when I'm doing something because I feel I'm supposed to, but because I truly want to.

My intuitive business coach, Dana Stovern, says the universe can't hear you when you say, "should, could, would, supposed to." It only hears you when you say, "I am," because when you say, "I am," you're making a declaration not just about what you want but who you are, and the universe takes note and rearranges itself to support you. In reflection, I've thought of several times in my life when this was true. When I said, "I am going to," or, "I will," and my life and finances shuffled around in mysterious ways to make those things possible.

No one says we have to stay in the same job forever. No one says we have to stay in the same *career* forever. We don't even have to work in the same mediums forever.

So, let's take a moment to reconnect with the things we love. Spend time listening to our wise inner voices. Recommit to that old hobby you used to enjoy, call a friend you've been missing, pull out that old creative project you set aside. Regain your positive energy and then put it back in the world in ways that benefit us all.

I'm pursuing happiness with no apologies. I'm going to become that person the old me would have looked at sideways.

Are you with me?

O

HOW TO WORK WHEN YOUR HEART IS BROKEN

Some of the greatest songs and stories are created by artists who have suffered a major loss or breakup. They channel all that pain, frustration, anger, confusion, disbelief, and sorrow into their creations, and we embrace those songs and stories because they speak to our suffering too.

Other artists, when faced with heartbreak, drop their art for a while as they work through their pain. It's sometimes years before they pick up a pen or paintbrush or instrument again.

Some artists create work just for themselves in order to process their sadness. They scribble furiously in journals or create sculptures they then destroy or write songs they crumple up and throw away. Their pain is private, but their art is still the best way to express it.

There's no right way to grieve, not even for artists. Whatever route you take, don't judge it. Trust you're where you need to be.

Be curious, though, because that is the strength of the artist. Don't run from the pain or anger or frustration; ask yourself why you're feeling it and how it's changing you. Try to understand why others might be feeling pain too or why they're not.

Let your thoughts flow. Don't stop them. They may take you to some dark places or to places that feel much lighter than you would have expected. Don't feel guilty either way. Stay in those thoughts for a while. Feel into them. Notice every emotion and wonder what it's telling you and where it might take you.

And when you're ready, pick up the tools of your trade and get back to work. In times of trouble, people need artists. We create those spaces where their own pain and worry and sadness can rest, and where their broken hearts can hope again. We don't have the answers, but we know how to pose the questions. And those questions start within us.

○

THE ART OF LONELINESS

Recently, I saw a group of business people enjoying a meeting over drinks at a coffeehouse. One moment, they were deep in conversation, the next they were laughing. Sometimes they debated, sometimes they nodded in agreement. And I envied them. They were uncovering some sort of important decision together, and all of their input helped to inform their conclusion.

I realized I was feeling lonely. I have plenty of friends and a family that loves me and lots to do. This is a different kind of lonely, and it took me a while to put a finger on it.

This is the loneliness of the artist, the person who is supposed to revel in sitting in solitude in his studio or office producing art. The person who is supposed to be best when left on her own and most productive when held apart from the distractions of a busy world. And it's true I need quiet and isolation to produce my writing, but producing art is only one part of being an artist.

See, on family vacations, I'm the one huddled over the maps and brochures trying to figure out what we'll do each day, but when it comes down to decisions, I can run them by my husband so he can weigh in. Off we go, both determining when

it's time to pull over for our picnic lunch or whether we should stop at that tourist site or just keep going. And at the end of the day, we talk over dinner about everything we saw and did, discussing what we learned and what impressed us, and arriving at interesting observations together.

As artists, the decisions often fall solely on us. And we spend a lot of time going round and round trying to figure out the right direction to take. Sometimes those decisions feel enormous and suggest dire consequences if we're wrong; other times they seem so trivial we wonder why we have to bother.

I love my work. I'm excited about my new projects, but I'm also feeling a little overwhelmed. Wouldn't it be nice to share the work ahead with someone else? To know he or she could carry part of the burden and share in the joys and sorrows? Oh, I know there are shared workspaces I could join, and, yes, it's true that venting to my artist friends helps.

But the fact is, every day I fall into a blank page, and that's a pretty lonely place. Until I fill it, of course, with stories or pictures or songs. For an artist, sometimes the only true way around loneliness is to get to work. I know that and I'll get back to that. But for now, I'm giving myself permission to experience whatever emotions I'm feeling and not just push them aside or try to move past them. What can I learn from this loneliness? What needs to change inside of me or in my external world in order to feel better? Could loneliness, one of the most challenging of human emotions, have a good side?

Bursts of Brilliance for a Creative Life

I found this quote by Henry Rollins: "Loneliness adds beauty to life. It puts a special burn on sunsets and makes night air smell better."

Okay, loneliness, show me the beauty. You're in the lead this time.

○

10,000 JOYS AND 10,000 SORROWS

Buddha once said everyone would experience 10,000 joys and 10,000 sorrows in their lifetime. I came across that quote the other day, and the number jolted me. It sounded so high! I mean, it's not hard to imagine 10,000 joys if you think of a joy as finding a pretty feather on the ground or eating a really good meal. But it was nearly impossible to wrap my head around 10,000 sorrows. That seemed so daunting. Must we really bear so much?

But then I asked myself why "sorrows" have to feel so much bigger than joys. Maybe our sorrows can be simple too, like feeling sad when a friend cancels a coffee date or when you find mold in your bowl of strawberries. Maybe sorrow doesn't have to refer only to the biggest, hardest things we endure.

There will be the immense joys, like the birth of a child or the moment you're handed that diploma, and immense sorrows, like the loss of a loved one or the betrayal of a close friend. But if you can start to see life as a balance, you come to understand in any given day, you can experience sorrow and joy, and they can live comfortably side by side.

In some ways, I think artists are more affected by this roller coaster than many people. Just going through my e-mail on

a Monday morning brings a constant stream of joys and sorrows. "Oh yay, a new book order! Oh no, my speaking gig fell through. Oh yay, I just signed a new business partner. Oh no, I didn't get the acceptance."

For far too long, I took only passing notice of the joys and dwelled for hours on the sorrows. What could I have done differently? Why didn't that person like my work? Did I drop the ball somewhere? Why did I put myself out there when I should've known it was a long shot? The joys seemed to be only momentary confirmation my hard work had paid off. The sorrows felt like heavy mistakes.

I'm not doing that anymore. I'm taking a moment to feel the joy, and a moment to experience the sorrow, and then I'm releasing them both back to the universe. They are all part and parcel of doing business. Sometimes the joys lead us to great new places and sometimes they turn out to be nothing. Sometimes the sorrows bring an end to something we cared about and sometimes they free up space for something better to come along.

It's not my job anymore to question what either of those things means or to spend all my time hoping and praying for the joys and beating myself up over the sorrows. I understand now you can't have one without the other, and neither is "better" or more important. They just are.

○

WHERE WORK AND WORRY MEET

Today, a close member of our family had major surgery, and another had a minor procedure. It's hard to focus on work when you're worried. You tell yourself everything will be fine and you must assume the best. You tell yourself you are "professional" enough not to let fear affect your work. After all, everything will likely be fine.

You try to push all your concerns to the back of your mind and do your job, but you jump every time you get a text, and you think you hear the phone ring when it didn't. You wonder if there's something more you should be doing or saying. You wonder if you should prepare for the worst or if that's jumping the gun. You remind yourself this is life. There are always going to be worries and distractions, and if you let them all get to you, you'll never get anything done. You tell yourself not to be such a worry wart.

And you go back to your desk and try, but your mind is foggy and your brain is tired and the focus just isn't there. So, you give up and accept it's okay to fall behind sometimes. Some things are more important. And you sit with the worry and the

fear and the emotions, because you know that this too is part of working and creating.

Someone once said, "You can have suffering without love. But you can't have love without suffering." And that struck me in so many ways. Sure, we'd have more time for our work and better focus if we weren't distracted by the people and things we care about. But would we have the heart to do the work we do? Would we have the empathy and compassion to make the connections we need to make?

Not long ago, I sent a poem to a contest with the highest of hopes and tremendous confidence. This piece of writing had seemed divinely inspired, like it flowed through me. And it was something I'd longed to write about for decades. In the end, I not only didn't place in the contest, I didn't even make it onto the long list. And after 25 years of writing and submitting, all the old worries and insecurities came flooding back. "Maybe you're just not good enough. Maybe you should give up writing and do something else. Great job, you once again misjudged what was 'meant to be.'" It was discouraging to think after all these years, I have not grown beyond doubt and insecurity and the hurt of being rejected.

But today has reminded me with love comes suffering. And I love what I do. I love writing. I dearly love that poem that didn't make it. I love the fact that I wrote a poem at all. I love that I got to feel high on hope and creation for the time it was under consideration.

Some weeks, everything goes our way. The good news comes in threes. The future looks bright. Other weeks, everything falls apart. Bad news comes in threes. The future looks dim. But through it all, our art is there. Love is there.

○

PIE IN THE SKY HOPES

When I was a kid, I used to sit on the back-porch step and sing at the top of my lungs the Frank Sinatra song, "High Hopes." Just what *did* make that ant think he could move that rubber tree plant? I had no idea what inspired his crazy dream, but I loved that he achieved it, despite all odds, and despite the fact that no one believed he could.

I still sing that song, and still at the top of my lungs, only now it's in the car or the shower or anyplace where the neighbors might not hear me. Because without high hopes, artists of any kind are doomed.

I wake up every morning thinking this will be the day George Takei calls to tell me he wants to make my book *The No-No Boys* into a movie, or Jane Lynch e-mails to ask if she can perform my one-woman show, *Dancing in Combat Boots*.

Every day, I send off e-mails and make phone calls and grant interview requests and go to networking events and throw all kinds of spaghetti at the wall in the hopes something will stick. And every day my husband shakes his head at me. Maybe he wonders when I'll give up my high hopes and settle for the good life I have. But that's never gonna happen.

Because we artists are only as real as our highest aspirations. We may produce great work day in and day out. We may meet all our deadlines and run our businesses correctly and pay our taxes on time, but without those crazy high hopes, there is no real passion. And without passion, there is no joy. And without joy, there is no genius.

And whether we ultimately achieve our wildest dreams doesn't really matter. It's the quest that drives us forward. So, go ahead and believe you will be the one to cure cancer or beat the world record in ski jumping or write the next "great American novel." And never stop believing it. Never stop working toward it. Because someday someone will do just that. Who's to say it might not be you?

○

CONVICTION IN THE FACE OF DOUBT

Recently, I listened to a speaker list three significant moments in her past when she doubted her ability to move forward, and how a key figure in her life told her each time, she could do it. His confidence propelled her onward. Things have not always been that way for me. At several important junctures in my life, a key figure told me I should not proceed. Though he thought I was clearly good at some things, *this* I could not do. While I would've preferred to have his faith in me, it was actually his lack of faith that helped drive me forward. Guess I had something to prove.

And that's how it feels sometimes. Sometimes we have support; sometimes we think we must go it alone. Sometimes many people believe in us, sometimes only one. Sometimes even when we have the backing of significant people in our lives, we still distrust ourselves.

In movies, the hero who changes the world always has that one mentor who says to her, "Never doubt yourself." And we in the audience nod our heads and say, "That's what she needed to hear. Now she's gonna kick some butt." But wouldn't it be truer if that sage character were to say, "Work past your

doubts. You can do this." Because even the greats must feel uncertain occasionally.

If courage is not the absence of fear but the ability to move forward in spite of it, then maybe conviction is not the absence of doubt but the ability to believe in spite of it.

We often know what's right for us, our families, our communities, our country. We feel it in our bones, yet we hesitate. We don't speak our minds, or make a stand, or advance our dreams because we worry we may be wrong or, rather, our naysayers may be right. But if you lean into your conviction, if you trust in what you believe, if you summon up that strength that is always, always inside you, you can say, "Thanks for your concern. But I think I'll do it anyway."

In the end, you might even be surprised that the people who first doubted you, come to respect you. Sometimes they can admit they were wrong, sometimes they can't. But chances are, a part of them will admire you for trusting yourself more than you trusted their cautions. And even if they don't, it doesn't matter. You have plenty of other people to support you. Heck, the whole universe supports you! One voice does not speak for all. And opinions are just opinions. What you believe matters more.

O

WHAT'S THE VIEW FROM YOUR LADDER?

The other day, I was listening to an interview with an established speaker who started out, as we all do, as an unknown. One day, through a bizarre twist of fate, a major company asked to partner with him, launching his career. We've all heard dozens of stories like his about artists who had a chance meeting with someone who later became their agent or their biggest client. There was a time when I'd hear those stories, look up at the heavens, and ask, "Why not me? I'm just as good as they are. I work just as hard. How come I never get a big break?"

After a while, though, I realized—for whatever reason—that was not to be my path. There would be no leaps up the ladder for me. I'd have to pull myself up one rung at a time. I know plenty of artists who've gotten their big breaks, and it's not always the blessing it appears to be. Suddenly they're working overtime to meet tighter deadlines, they're pressured to deliver a different type of work than they would like to produce, and they're required to take on myriad difficult new tasks. We should never begrudge those who "got it easy," because in the arts, there's no such thing.

I no longer spend all my time looking up the ladder anyway. There's something to be said for pausing wherever you are and taking in the view from that rung. It's an ever-changing scene, and it's fascinating. And sometimes, it's good to look down too, and note just how far you've come. Life is long. There's plenty of time to get where we want to be. In the meantime, why not enjoy the climb?

○

Bursts of Brilliance for a Creative Life

Conclusion

You say you're not an artist, then you cut a perfect leaf into the top of the pie crust.

You say you're not creative, but you make up puns on the spot.

You say you're not inspired, then you write the perfect encouragement into that graduation card.

You say you're not inventive, but your homemade Halloween costume blows everyone away.

You say you're not gifted, then you stand up at your daughter's wedding and sing and everyone cries.

You say you've never been visited by the muse, but you assemble a beautiful bouquet of flowers to give your friend on her birthday.

You say you're not unique, then you sign your name with your own special flourish.

You say you're not good enough or smart enough or talented enough to be an artist, then you remember a time when you didn't doubt yourself. A time when you were little and were every kind of artist at once. You drew pictures that were good

enough to be hung on the fridge. You did dances that made your relatives clap with glee. You made up poems about your broccoli and your parents laughed. You knew you were an artist, and you loved yourself for that.

You still are. You always will be. It's time to love your artist self again.

I recently met with a friend who is a stay-at-home mom, as I once was. She was lamenting how hard it is to find time to write with all the responsibilities of house and kids. I passed on a piece of advice a friend said to me when I was lamenting something similar many years ago. She said, "Your kids will never remember how clean or dirty your house was. They will remember, though, a mother who worked hard every day at something she loved and believed in."

Can we, as parents, grandparents, aunts, uncles, teachers, and friends, truly be role models for the children in our lives if we don't follow the same advice we give them? Can we expect them to "follow their dreams," when we don't do the same? Can we expect them to "never give up," when we do just that? Can we expect them to "work hard to achieve what you want," if we don't let them see us working hard too?

When I was that teenager taping inspirational quotes to my mirror, I was looking for reassurance my talents were gifts for me alone and I must use them or lose them. Ever since I was in the fifth grade, I wanted to be a writer. And through all the ups and downs, I never stopped hoping that would happen.

But I also knew I'd never be a writer unless I actually *wrote*. There was no shortcut to success. I couldn't just dream about it. I had to do it.

It's never going to be easy to find time for our art, but we owe it to the dreamer inside each of us to somehow make it happen. The universe will back up our dreams, but only if we work toward them. You can't just wish them into being or pray them into existence. You have to determine to live them, each day, every day.

So, let's encourage each other. Let's tell the artists in our lives—whether they're professionals or hobbyists—their work matters, and not just to them. Though their finished art may someday impress or move others, just the act of their working will inspire us even more. Remember: *We* make the things that matter, matter.

○

Acknowledgments

For years, some of my writer friends told me I should write a blog. I resisted for a number of reasons. First, I thought too many writers had blogs. What could I possibly say that was different? Second, I didn't want to provide writing advice and coaching, which seemed to be what many of them had in mind, because so many bloggers were doing that pretty well already. Third, I knew I couldn't commit to the consistency of a blog unless I landed on a topic that would excite me enough to write about it every week without fail.

And then one day, it came to me. I wanted to write a blog about living the life of an artist and an entrepreneur. I wanted to share my experiences and encourage others, but also to do what I'd done for years in my personal essays and literary writing: uncover myself! Well, that sounded a bit scary. Engaging in public self-exploration would put me in a pretty vulnerable place. I set the idea aside for a bit, but it kept nagging at me. This blog wanted to be written.

Over time, the blog started to attract a loyal following. People would send me e-mails to tell me that a certain post made them cry or that it was just what they needed to hear. And to

my surprise, it wasn't just writers and artists who were reading my scribblings, it was business people and teachers and health care providers. So, I kept going. And after a few years, I started to wonder if the blog might one day become a book. And it has, with the support of many people.

My thanks go first and foremost to my writer friends who first championed this blog and what I wanted to say, but also championed my search for my Higher Self. They shared their insights and intuition and encouragement in all the right ways and helped me learn to trust my own inner guidance. In alphabetical order: Trai Cartwright, Karye Cattrell, Colleen Crosson, Kit Gregory, Victoria Hanley, Sandy Scott, Susan Skog, and Natasha Wing.

To my teachers who taught me *how* to access my greater intuition, Jannie Williams, Janet Potts, and Dana Stovern.

And to my writer friends who offered support and suggestions for the book, Laura and Jon Backes, Gary Raham, Linda Osmundson, Jim Davidson, Pat Stoltey, Jeana Burton, Sara Hoffman, Leslie Patterson, Elisa Sherman, Melinda Swenson, Debby Thompson, Karla Oceanak, and Katherine Valdez.

To my amazing developmental editor, Alexia Paul; my favorite copy editor, Jennifer Top; and my talented e-book designer, Veronica Yager.

And especially to artist-extraordinaire, Amelia Caruso, for the cover image, and designer-extraordinaire, Launie Parry, for the cover design.

And, of course, to my assistant, Katie Huey, who has offered help in whatever ways I could possibly use her. Why? Because she believes in me, my writing, and my message. She knows everything I said in this book is true because she's honoring her Creative Self too!

And to my always supportive husband and children, Roger, Brian, Lydia, and Ava. Their very presence in my life feeds my soul and my art.

Special thanks to longtime friend, Dr. Peter Springberg, one of my most ardent and consistent supporters and a creative himself.

And especially to all my loyal blog followers. Without you, this book would not exist!

O

About the Author

Teresa R. Funke is a writer, speaker, and blogger. For almost three decades, she has written articles, essays, and short stories, as well as seven books for adults and children set in World War II, including *Remember Wake, Dancing in Combat Boots: and other stories of American Women in World War II,* and the Home-Front Heroes Series of books for middle-grade readers. She also worked as a writer's coach and created numerous videos, masterclasses, and blueprints about writing and publishing. You can find those and other writing resources at her website www.teresafunke.com.

Teresa started her blog, *Bursts of Brilliance for a Creative Life,* in June 2014. That blog was the inspiration for this book and led to many unique collaborative efforts, including concerts with singers, radio appearances, invitations to read the blog at gatherings and events, and her Bursts of Brilliance talks for conferences, events, and meetings.

Teresa is a sought-after motivational speaker for adults and youth, and a popular presenter.

She loves to read; travel; go to movies, concerts, and theater performances; and have long, meaningful conversations about

art and what inspires us. What she likes best, though, is spending time with her husband and three grown children.

Visit www.burstsofbrilliance.com to find more resources, materials, and connections to ignite your Creative Self.

O